Painting
in
Watercolours

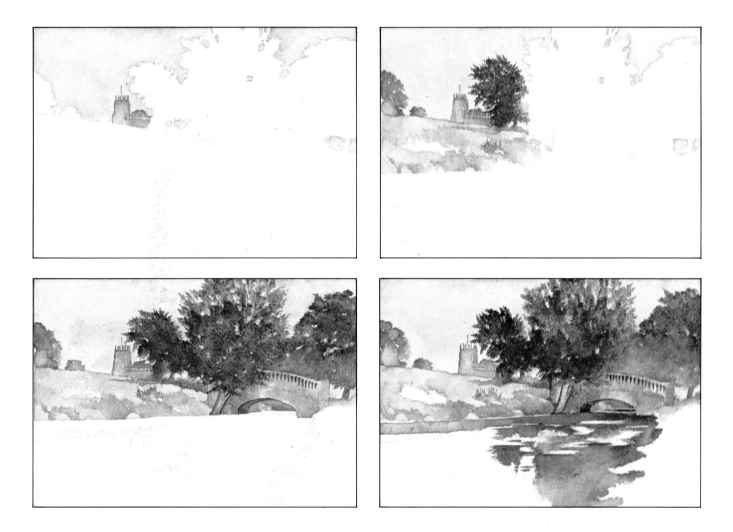

Also available in the same series

PAINTING IN OILS

PAINTING WITH PASTEL

DRAWING FOR PLEASURE

PAINTING ANIMALS IN WATERCOLOUR

PAINTING THE SECRET WORLD OF NATURE

The Authors

Leslie Worth, who studied at the Royal College of Art, lives in Surrey on the edge of the North Downs. Until recently he was Head of the Fine Art Department at Epsom School of Art and Design. He is a full member of the Royal Society of Painters in Watercolours and the Royal Society of British Artists.

Jan Burridge trained at Leicester College of Art and the London College of Painting. She worked as a designer before turning freelance to specialise in design and illustration. She lives in Sussex and exhibits in galleries in Kent, Sussex and Gloucestershire.

Richard Bolton was a technical illustrator before he turned to painting full-time in 1979. He lives in Cambridgeshire, and exhibits in several galleries in London and in Boston, Mass.

John Blockley, who has had many one-man shows, has a painting studio in a 16th-century barn in the Cotswolds. He runs private painting courses in the summer throughout Britain and serves on the councils of the Royal Institute of Painters in Watercolours and the Pastel Society.

Sarah Jane Coleridge, who died in a car-crash in 1981 shortly after her *Painting Flowers in Watercolour* was published, taught herself to paint flowers and developed her own distinctive style from hours of study and the desire to capture fresh bright colours.

Painting
in
Watercolours

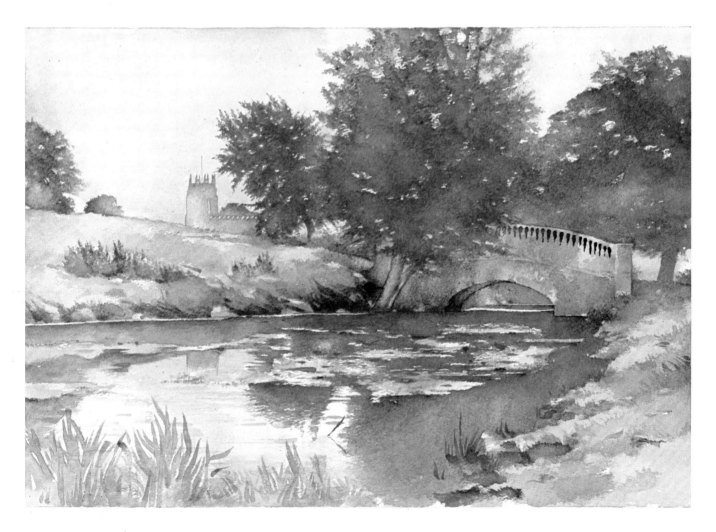

**Leslie Worth Jan Burridge Richard Bolton
John Blockley Sarah Jane Coleridge**

SEARCH PRESS LTD
Tunbridge Wells, Kent

First published 1982

Search Press Ltd
Wellwood, North Farm Road,
Tunbridge Wells, Kent TN2 3DR

Reprinted 1984, 1987, 1988, 1991

First published simultaneously in paperback 1982

Pan Books Ltd
Cavaye Place, London SW10 9PG

Reprinted in paperback by Pan Books Ltd 1984, 1985, 1987, 1988

Reprinted in paperback by Search Press Ltd 1991, 1992

Based on the following volumes of the Leisure Arts series first
published by Search Press.

Working with Watercolour by Leslie Worth
Laying a Watercolour Wash by Leslie Worth
Painting Landscapes in Watercolour by Jan Burridge
Painting Sea and Sky in Watercolour by Leslie Worth
Painting Detail in Watercolour by Richard Bolton
Creative Watercolour Techniques by John Blockley
Painting Flowers in Watercolour by Sarah Jane Coleridge

Edited by Yvonne Deutch
© Search Press Ltd 1980, 1981, 1982

ISBN 0 85532 517 8 (hb)
 0 85532 704 9 (pb)

Made and printed in Spain by A. G. Elkar, S. Coop.

Contents

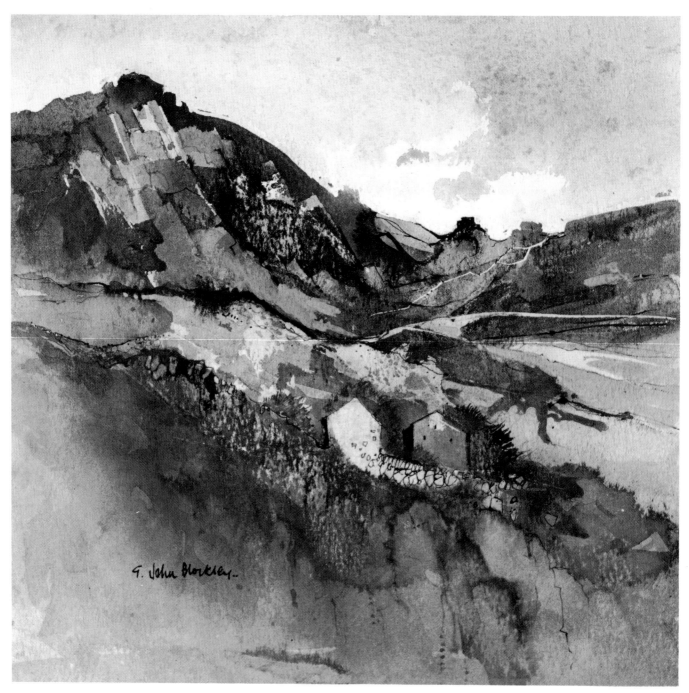

Mountain by John Blockley

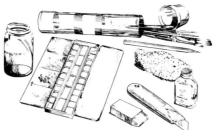

Materials and Techniques
by Leslie Worth & Jan Burridge

Introduction

Watercolours are, as their name suggests, pigments ground in water and bound with gum or a similar substance. Painting in watercolours was one of the earliest arts discovered by man, and has continued in various forms over the centuries until the present day, when there is a reawakened interest in its use.

Watercolour painting is essentially a small-scale art form, but it is capable of rich and personal expression. It is important to recognize limitations and exploit these to advantage. Watercolours call for clear thinking and spontaneity of action, for exploration of the balance between broad masses of colour and linear patterns, and for the contrasting of limpid washes of colour and sharp, active brushstrokes.

Water is both one of the ingredients of the colours and the vehicle in which the colours are applied – and to use the medium successfully, you must learn to control the delicate balance between the water content and the amount of pigment picked up on the brush.

Many people think that this means a full brush and great floods of water on the paper, and 'the wetter the better'! This is not so. When learning to handle the medium, it is a good idea to err on the lean side and to use only just sufficient water. With experience the water content can be increased.

Anyone who paints with watercolours soon realizes that the medium has a life of its own, which can be exploited but rarely completely subdued. The washes are governed by the force of gravity and the colour will tend to run down the paper, especially if you are working on a tilted board; wet areas will 'bleed' into one another; and furthermore, the colour will dry out rapidly, or not at all, depending on the humidity of the atmosphere. Every watercolourist must learn to anticipate the colour values in advance and make allowance for the loss of tone when the water evaporates.

How to use this book

The five authors contributing to this book have each provided special demonstration paintings and direct, step-by-step commentaries on their work. This gives you an orderly structure, while at the same time the overall approach is informal and very practical. Learning to paint this way is a relaxed and pleasurable experience.

The book is arranged so that you progress steadily from the basics to more advanced stages. You start with foundation techniques such as choosing your materials, mixing colour, laying washes and developing sketching, drawing and composition. Eventually you build up quite esoteric skills such as using wax resist and other 'tricks of the trade' to create interesting textural effects.

Extensive attention is given to the 'classic' subjects – landscape and seascape – and you are also encouraged to learn how to do detailed studies which demand control and excellent concentration. Since so many people love painting flowers, this has also been included, and adds a delightful extra dimension to your expertise.

Although the way you use this book will be entirely personal, it is worth noting that many people find it useful to follow through the demonstrations step-by-step until they gain confidence and fluency, and then choose a subject from life which demands the same techniques.

Whatever approach you use, once you have learned to use it, you will discover that watercolour has a beauty and an inner poetry unrivalled by other forms of graphic expression. It is perfectly conceived for conveying the moods and vagaries of light and colour, and its immediacy and delicate sensibilities make it ideal for capturing those fleeting moments of experience denied to more ponderous and premeditated media.

Paper

The paper you use will influence your painting more than any other item of material. Its characteristic behaviour, determined by its manufacture, will dictate the range of expression and thus the ultimate character of the work. So it is essential to understand the nature of each paper and to choose carefully. You will need to experiment to find which surface suits your own purposes best.

Paper is made up of a close web of interlacing fibres which trap the tiny particles of colour, and according to the density and irregularity of the fibre mat give sparkle and vitality to a painting. Generally an irregular surface will yield a livelier effect than a smooth one.

You may of course paint on any paper, but there are papers made specifically for watercolour painting.

These are sized during manufacture so that colour may be spread evenly over the surface and succeeding layers built up without too much loss of luminosity. In practice this sizing varies even among papers of the same type – so again you will need to experiment to discover the various behaviour patterns.

Watercolour papers are divided into two main categories, handmade and mould-made (machine-made). Handmade paper is characterized by an individual and relatively irregular surface. Naturally, it is expensive. Mould-made paper is regular in surface and cheaper, but perfectly adequate for working on.

Both papers are made in three surfaces, *Hot-pressed*, *Not* (Cold-pressed), and *Rough*: basically, smooth, medium and rough surfaces respectively. They are classified by weight, in either grams per square metre or pounds per ream (500 sheets), for example 150 gsm/ 72 lb., 635 gsm/300 lb.

To avoid cockling, stretch the paper before using it. Immerse the paper completely in cold water for a few minutes, then remove it and lay it flat on a stout board. Take up the surplus water with clean blotting paper (do not rub!) then stick the paper down on the board with gumstrip (adhesive-backed brown paper strip) around the edges, sticking approximately one third of gumstrip on the paper and the remainder on the board. As the paper dries out it will contract and pull tight like a drumskin. Be sure to lay the board perfectly flat while the paper is drying.

Brushes

Art supply stores stock a wide range of brushes, many of which are not suitable for watercolour work. The best kind to use for this purpose are sables. They are expensive, but are beautifully soft and springy, and return to their original shape after each brushstroke, thus ensuring good control.

Oxhair brushes are much cheaper; they are also coarser, and have more spring, but they are useful in less delicate wash-work.

Squirrel hair brushes should be avoided. They are often sold under the name of 'wash brushes', but they are too floppy to be genuinely useful.

Chinese bamboo brushes are a useful and economical buy. Although they look unconventional, they handle extremely well, and since they come to a fine point, they are good for detailed work such as grasses and branches of trees. For really fine work, however, you should use a no. 1 sable.

Brushes are numbered so that the smaller sizes are described in low numbers, and the larger in high numbers. There is also a variation in the shape of the heads. The basic shapes are round, flat and filbert – the latter being a shape between round and flat.

Choosing a brush

Do not be afraid to ask for advice in the store, but remember also that the best policy is to spend as much as you can afford on a small but well chosen selection. A basic guide is to buy a no. 1 sable augmented by Chinese bamboo brushes for fine detail.

For the middle range, one each of sizes 4, 7, 8, 10 or 12 will be adequate. Finally you will need a brush with a large head for extensive wash work. For this you should buy a 25mm (1 in.) flat sable. As you pick out your brushes you should test each one. The store will usually supply a small pot of water.

Select a few brushes of the size you need and dip each one in the water. Give the brush a single, vigorous flick, and choose the one that returns to the best point, and retains its natural shape most easily. You do not need to test Chinese bamboo brushes, as the bristles are soaked in a special hardening solution to maintain their wet shape.

Caring for brushes

Good quality sables will last for several years if they are cared for properly, while cheaper brushes deteriorate within a few months. Since good brushes are expensive, it is vital that you know how to look after them. Here are a few pointers to follow:

1. Treat the brush respectfully; avoid hard scrubbing with it.
2. When you have finished using it, rinse the brush very thoroughly in clean water. Make sure there are no hidden particles of paint clogging the ferrule (the piece of metal in which the hairs are set).
3. If the brush becomes very discoloured, clean it with good quality soap, then rinse it thoroughly in plenty of clean water.
4. After washing, shape the brush with your fingertips, or between your lips if it is clean, and set it aside to dry.
5. Never put wet brushes away in a closed container.
6. Protect the tip by carrying brushes fastened to a metal or wooden strip in a brush carrier. Remember that the protective strip must be longer than the brush in order to protect the tip.
7. Individual brush tips can be protected as follows. Make a small tube with a piece of stiff paper which will fit over the head of the brush, and secure it with sticky tape.

Other materials

One of the advantages of painting with watercolours is that you do not need an array of expensive equipment. In addition to brushes, paper and colours, you will need a good drawing board; clean containers for water (jars with screw top lids are useful); mixing palettes (improvise with clean white plates or saucers); some pencils for preliminary sketch work (H.B. are the best quality); an eraser (choose a soft putty type which will not damage your paper).

If you are painting outdoors, you will need an easel to prop up your drawing board. Buy the best one you can afford. Other materials, such as masking fluid, which are used for special effects are indicated in the text where these techniques are described.

Brushstroke made by a large flat sable.

A Chinese bamboo brush produces beautiful tapering lines ideal for grass and branches.

A no. 1 sable makes all fine lines and small details.

Colour

Watercolours are basically pigments ground in water and bound with gum. They also contain glycerine to keep them moist and a 'wetting' agent.

They are sold in pans, either half or whole pans, tubes, or cakes. Pans are convenient to use, for the colour can be controlled easily. Tube colours are ground to a more liquid consistency. They are useful for painters who use a lot of colour, but are less easily controlled.

Cakes are small rectangular blocks of solid colour and need to be rubbed to release the colour. They are chosen by the purists, but inexperienced painters tend to find them difficult to use.

Manufacturers sell watercolours in two qualities – Students' colours and Artists' colours. The Students' colours are much cheaper, but again, the price reflects the quality, and it is best to use Artists' colours. The rich colour, the covering power and the delicacy more than compensate for the extra outlay of money.

Good artists' materials shops issue cards showing the range of colours and their relative degrees of transparency, and it is advisable to study these before buying your colours. A basic range of eight or nine colours is all that is necessary. A reliable basic palette might consist of:

Yellows aureolin, raw sienna
Reds light red, vermilion, alizarin crimson
Blues Prussian blue, monestial blue, indigo
Auxiliary colours might include chrome orange, sepia, brown madder, cobalt violet.

There are other kinds of watercolours available called 'gouache' colours. These include powder paints, poster paints and designers' colours. They are all opaque, and are intended for areas of solid 'body' colour. Consequently they are not suitable for the pure, transparent watercolour techniques generally used in this book. Where an opaque effect is required, in distant sky effects for example, transparent watercolour can be made opaque by mixing in Chinese white – which can be purchased in tubes, pans and small jars.

A basic palette

The eight colours shown have been chosen to give as wide a potential as possible. However, a basic palette is finally a personal choice, and you will eventually want to make your own modifications.

The eight colours are painted out in strips, starting at near full strength and diluting to a pale tint. Then at right angles to this are painted four bands of colour. You will see from this how other colours are created by optical mixing (laying one colour over another), and also to what extent basic colours may be modified by mixing and diluting.

You may find it useful to make a similar grid, and see what other facts of colour behaviour can be observed.

Key

1. Aureolin: a sharp, clear yellow, rather gentle in action.
2. Raw sienna: an essential earth yellow, warmer and less muddy than its closest relative, yellow ochre.
3. Light red: a delicate earth red which may safely be used in the quietest passages and yet, used pure, is capable of vibrant energy.
4. Vermilion: an apparently brilliant colour which is in fact very quiet in behaviour.
5. Alizarin crimson: a strong, purple red which is useful in certain circumstances but must be used with care, as it bleeds into other colours.
6. Prussian blue: a beautiful cool, clear blue, quiet in spite of apparent pungency. It produces clear greens and subtle greys in mixing.
7. Monestial blue: a modern colour, strong and vibrant, somewhere between Prussian blue and ultramarine blue.
8. Indigo: an old favourite, of great range and power, graduating from near black to soft grey.

Cross bands are made from the following colours:
a. Prussian blue c. Vermilion
b. Alizarin crimson d. Aureolin

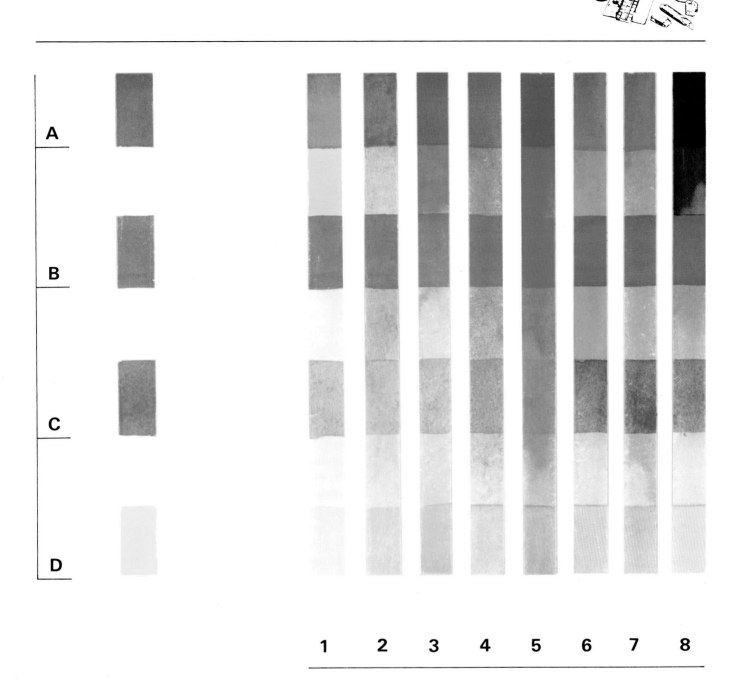

A B C D

1 2 3 4 5 6 7 8

N.B. You will note that the palette contains no greens. The chart illustrates how some greens may be made by mixes of various blues and yellows.

A basic palette. Make gradations of eight colours and experiment with mixing and overlapping.

Basic techniques
Laying a wash

Commentary and paintings by Leslie Worth

Transparent watercolour, as opposed to body colour or opaque watercolour, depends for its effect upon the reflection of light through layers of translucent washes of colour from the white paper beneath. Clearly then, experience in knowing how to make use of, or reduce, this reflected light is a fundamental principle of using the medium successfully.

Obviously, for a pale translucent wash you use very little colour with water; but to produce a heavy dark wash, overlay successive thin washes of colour or increase the amount of pigment used.

The quality and surface of the paper you use is crucial in determining the quality of the surface colour. A robust, well-sized paper is more likely to yield vibrant washes of colour than a thin smooth surface. Experiment with different types of paper and with the amount of pigment you use until you can decide which is most suitable. The initial washes of a painting are the most important. Sensitively used, they determine the mood of the painting. They serve to unify different elements of a picture, and form a basis for other nuances by superimposing washes of complementary colours. Look, for example, at how Turner and Cotman (and indeed other artists) carried the colour of the sky through the buildings or foreground subjects in their watercolours.

Apart from the initial preparatory washes in a painting, the use of the wash throughout the painting, in large or small areas, is the chief means of shaping the work and giving definition to the forms.

In the examples which follow, I hope some of these principles will become apparent. It is very difficult to carry out a comprehensive survey of all the possibilities – but I hope that, from the examples given, you will understand the basic principles and extend the range through your own practice.

The first two examples on page 13 illustrate the perfectly flat wash, and the technique for laying an even wash on a damp surface with alternate movements of the brush as it moves down the paper to ensure an even distribution of colour. Stretch the paper beforehand and keep the board tilted at a gentle angle, propped on a thick book if you have nothing more sophisticated.

The graduated wash, as illustrated in example 3, is a situation you are more likely to encounter. Add progressively more water on to a damp surface, but avoid making the paper too wet.

Example 4 illustrates how to build up density by overlapping more washes of the same colour. Although some detail is lost by using only one colour, the important point is that the same colour mix was used throughout; therefore the increase in tone is simply a multiple of the same basic wash. After five layers there is practically no change in the depth of colour.

To achieve the effects in example 5 (page 14) vary the speed of your brushstrokes. This is an important and subtle technique. It can be compared with the action of a violinist when drawing his bow across the strings: a slow steady pull will not produce the same quality of sound as a sharp movement even when the notes are identical.

Example 1

This illustration shows the method of laying a flat wash. Pass the brush across the paper alternately from side to side and work down the paper. Alternating the movements avoids a build-up of colour on one side of the paper. Mix enough colour so that you only recharge the brush at the end of each movement, thus maintaining an even colour.

Example 2

It is rarely necessary to lay a perfectly flat wash, but the practice is useful. Damp the surface a little before starting so as to avoid hard edges. Stretch the paper and tilt the board at a gentle angle to encourage the wash to diffuse for a more even spread of colour.

Example 3

This colour wash diminishes downwards and is a typical situation when painting a clear sky. First damp the paper and apply the first brushstroke across the top of the area. Continue working across the paper, beginning each stroke from alternate sides, and gradually increase the water content to pigment on the brush as you

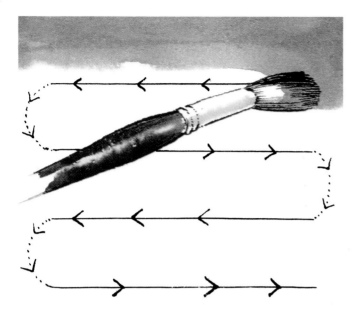

Example 1

Example 2

Example 3

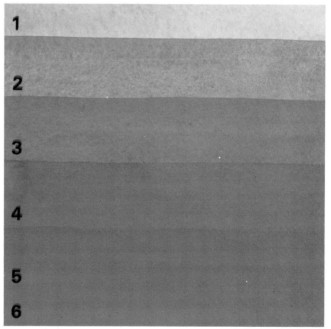

Example 4

descend the paper. Be careful not to make it too wet. You will probably use a graduated wash very often so practise this technique as much as you can to ensure a really *even* graduation.

Example 4

Start by laying a flat wash of colour over the paper. When this is dry add a second wash, beginning an inch (about 25mm) from the top. Lay a third wash two inches (about 50mm) from the top and continue in this

way until maximum density is built up, usually by the fifth or sixth wash. Notice how the luminosity of colour progressively disappears until the difference is almost indiscernible and the colour is totally flat and dark.

Example 5

Demonstrations of characteristic brushmarks:
a. A flat wash laid in carefully and slowly on a dry surface.

a

b

c

d

Example 5

b. The same colour laid in carefully and slowly on a wet surface.

c. The same colour laid with swift strokes on a dry surface.

d. Swift strokes of the same colour laid on a wet surface.

The speed with which you pass a brush over the paper determines the type of mark. Notice how tone is lost in the wet areas, how the outlines are much harder in the dry areas, and how the surface breaks up in c. giving a very rough texture.

Simple colour combinations

Commentary and paintings by Leslie Worth

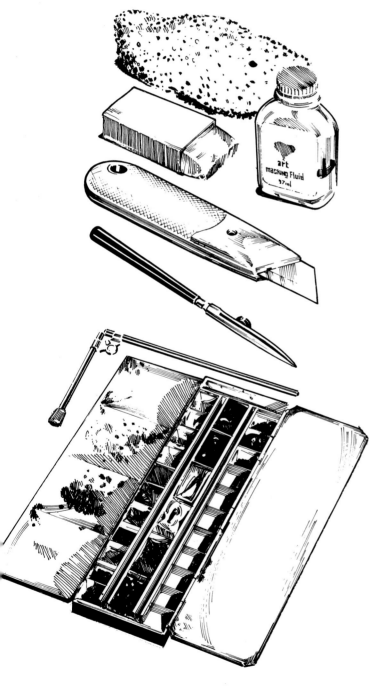

Probably the most attractive aspect of watercolour painting is its economy of means: a powerful painting can be produced with few colours. Most of John Cozen's work was done with two colours – a cool blue and a madder. Without wishing to invite comparisons, I have tried to show in these examples that two colours can give a really wide range of expression (pages 16–17).

In example 1, bands of orange and blue are laid alternately and progressively down the paper to show that the colour produced by laying orange over blue is not at all the same as that produced by blue over orange. Only experience and practice can help you build a working knowledge of how one colour reacts when laid on another.

In example 2, the boat in moonlight shows how a picture can be built up completely with just one colour. In this case I used indigo.

The painting of the beach with the striped wind-break was done entirely with two colours, Prussian blue and a chrome orange. Although the blue of the sky and the orange of the beach are not very subtle, they illustrate the point effectively.

First I established a general wash of colour overall to provide a framework on which to build. The painting shows sharp as well as soft-focus areas, according to where the washes are taken across either dry or damp surfaces. Generally speaking, warm areas of colour dominate and cool areas recede (although the reverse can be achieved in certain situations).

I tried to show the contrast between the soft billowy cloud and the hard, clean surface of the sand. This is a good example of painting into a dry or wet ground to demonstrate the different qualities of a subject.

Example 1 *(overleaf)*

A simple chart showing what happens when thin washes of blue and orange are overlaid.

Lay a flat wash of pale orange over the paper. When the paper is dry, lay a wash of pale blue over the lower four-fifths, then orange over the lower three-fifths, blue over the lower two-fifths and a band of orange across the bottom. When dry, put a wash of orange across the right half and then blue over the right quarter.

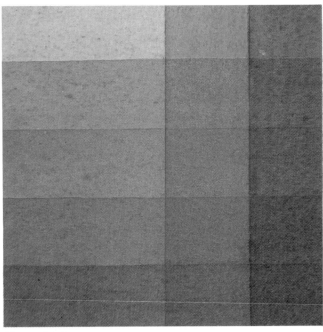

Example 1

orange	orange on orange	blue on orange on orange
blue on orange	orange on blue on orange	blue on orange on blue on orange
orange on blue on orange	orange on orange on blue on orange	blue on orange on orange on blue on orange
blue on orange on blue on orange	orange on colour as left	blue on orange on colour as far left
orange on blue on orange on blue on orange	orange on colour as left	blue on orange on colour as left

Key to example 1

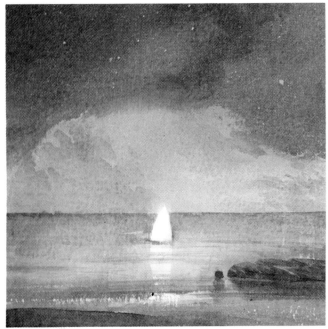

Example 2 – Dinghy in moonlight

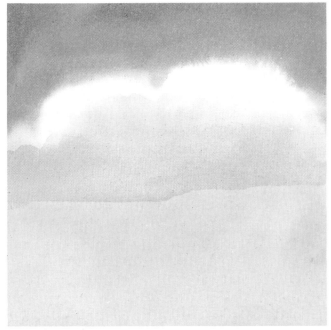

Stage 1

The results differ widely and show that a totally different effect is achieved when blue is laid over orange than when orange is laid over blue. It also demonstrates how quickly colour control and all-important luminosity are lost if too many washes are laid one on top of the other.

Example 2

Dinghy in moonlight is a study using only one colour. Make a sketch to establish the relationship of areas of tone to one another, e.g. the clouds to the sea surface. Try to limit the tones to no more than six so as to avoid confusion. Decide the order of precedence from light to dark; use pigment sparingly to start with and increase it as you feel more confident.

Paint a pale wash of indigo overall; then lay indigo in overlapping washes from light to dark.

Stage 1

These are the preliminary washes for *The striped windbreak*. Overlay subsequent colour mixes into either dry or damp surfaces, depending on whether you want a hard or soft edge. Paint the sky and clouds into wet paper, using very fine veils of colour. See pages 32–34

16

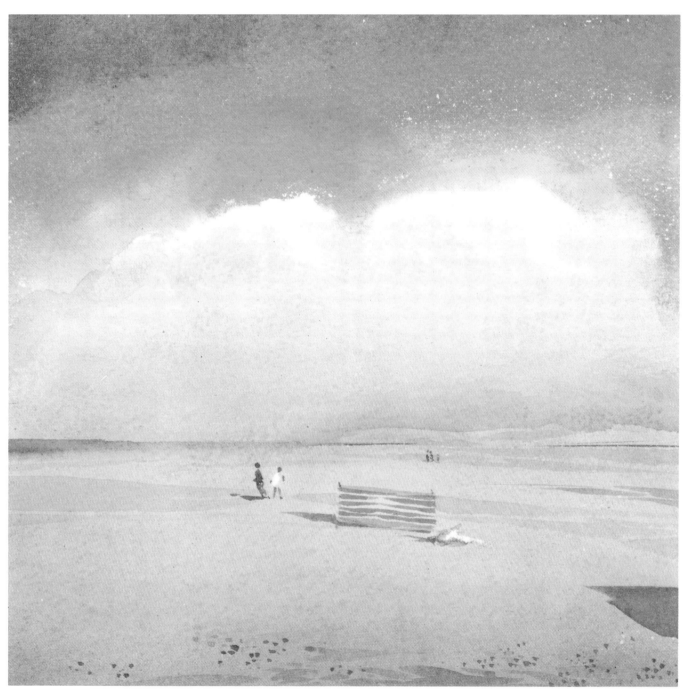

Stage 2 – The striped wind-break

for clouds. Paint the sand on to dry paper to give a harder tone and a sharper horizon. A hard-edged subject needs a hard-edged treatment. If you tried to paint a flight of stone steps wet-into-wet, there would be no hard edges and the result would be unconvincing.

Stage 2

This painting demonstrates the range possible when only two colours are used. Do not mix the colours in the paint-box, but lay them pure, and dilute them in varying degrees as required into a dry or damp ground.

The sky is complete at the end of stage 1. Work at this stage consists of adding detail to the land. Put in the sea on the left with a hard top edge and a soft lower edge to give an impression of surf and foam on the shore. Very thin streaks of blue on the sand give depth, form and modelling to the middle distance. Balance the sea on the left with two shadows coming in on the right, and spatter in some assorted dots of blue and orange in the foreground to suggest pebbles.

Lastly put in the wind-break, the two figures to the left of it and three smaller figures above to give the feeling of a wide expanse of sand.

17

Stage 1

Stage 2

Stage 3

Stage 4

Watercolour sketching

Commentary and paintings by Jan Burridge

As you work in watercolour, you will soon find how useful it is to be able to work quickly. It is essential, for instance, when painting a sunset where lighting effects change rapidly. Detail can be important, but too much attention to it can make work look over-intense and unattractive. I taught myself to draw quickly by setting myself a specific time within which to complete a drawing. I still do this now and again to keep in practice. It is always a good idea to draw as much as you can, but now and again you should set yourself a time target for a satisfactory drawing. Attention to detail will suffer, but your ability to capture an accurate impression on paper will improve rapidly. I often find that a quick impression is more vivid and true to my intention than a ponderously detailed work.

Demonstration

Size: 265 × 190 mm/10½ × 7½ in.
Brushes: 1, 2, 4 sable. Paper:
Bockingford 285 gsm/140 lb.

Stage 1

Make a fine pencil drawing of the cloud shapes and establish the horizon on the paper. Paint the sky with a broken wash of ultramarine, Prussian blue and hooker's green. Vary the tone to produce uneven patches of light.

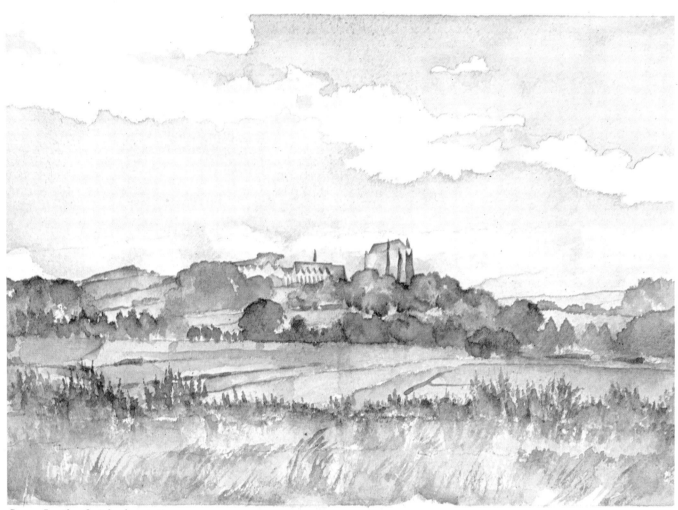

Stage 5 - the finished painting

Stage 2

Colour in the tall buildings and roof-tops, and distant fields that catch the sunlight. Mix Prussian blue, crimson red and sepia for the shadows which the buttresses cast on the walls. This is a sketch and not a painting, so do not spend too much time trying to obtain perfect hard or soft edges on each area of colour. Let all these light parts dry.

Stage 3

Add the clusters of trees on the hillside, the thin conifers and full deciduous trees in the middle distance. Use sap green, sepia and Prussian blue with touches of burnt sienna. If the green trees are too heavy, lift out some wet colour with a clean brush as I have done just below the tall central building. While the paint is still drying, lightly pencil in the foreground details.

Stage 4

Make up thin washes of yellow ochre, sap green and burnt sienna and lay in the low-lying fields on either side of the river. A few dark horizontals give greater distance to the trees and buildings. Paint the river with the colours you used for the sky in stage 1.

Stage 5

Complete the painting with bold brushstrokes of raw umber, yellow ochre and burnt sienna for the rows of stubble and dry grasses in the foreground. If you apply the paint too thickly the effect will be too heavy.

This is not an outstanding painting, but a successful sketch (it took less than half an hour).

Drawing

One of the best ways to improve your watercolour work is to develop your drawing skills. Good drawing is the foundation on which to build your painting, and the only way to improve it is to practise constantly. The ideal method would be to try to draw something every day. It does not matter what you draw so long as you work directly from life. Draw articles in the home, or when out walking, bring back shells, pieces of bark from trees and any other interesting objects. Your main aim is to produce accurate drawings. It is easy for a beginner to be content with a superficial likeness of a subject, but improvement comes only from continually analyzing your drawing, no matter how experienced you are, and by developing a strongly critical approach to your own work.

It is useful to keep a sketchbook so that you can look back over your work to see your mistakes and improvements. You will find that drawings which pleased you in the past no longer satisfy you. Try not to waste pages in your sketchbook; use each page fully and always finish each drawing.

Joining art classes can be a great help in working out ideas and encouraging you to improve your technique. Visit galleries and read art books as these can often be sources of inspiration. Try to build up a small library of your own.

For watercolour painting, all you need is a simple, accurate line drawing to guide you in your painting. Use a HB pencil for drawing as hard pencils scar the paper and soft ones leave too heavy a line. Occasionally it is useful to have strong lines in your painting, for example in an architectural subject that has many straight lines. Keep your pencil sharp and try to produce clear, crisp line work. Avoid using a sketchy technique that leaves ugly, feathery lines, and always try to leave a drawing with as few lines showing as possible.

Here is an example of how composition can be influential in shaping a drawing. The original scene for the top drawing appeared exactly as it is shown here. In the new drawing (below) the basic composition was altered. The barbed wire fence was removed, the farmhouse was made larger, and the cart track was curved further to the right.

Composition

Practice in drawing is an excellent way of developing yet another important skill – that of composition. In flat terms this means the arrangement of the various elements in a picture so that they add up to make a harmonious whole. Good composition is in fact a most powerful, active factor, involving a total balance of form, colour, space, rhythm and tone in pleasing proportion. Composition involves selection from what you see, so that you are 'editing' the view in front of you into a new creation.

Basic errors in composition always stand out. Five minutes spent on a quick sketch or working plan is rarely wasted, and it is also an invaluable way of discarding initial errors. You can simply erase them before you start painting.

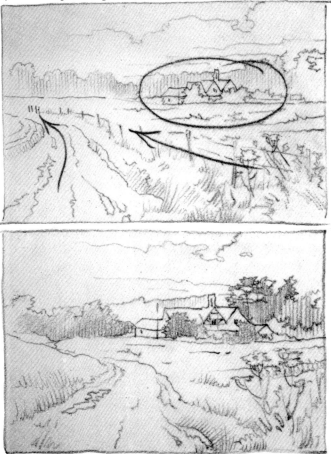

Painting outdoors

Because of its sensitivity in recording changes of light and atmosphere, watercolour is particularly suited to outdoor painting, whether of quick studies or more complete works. There are some problems involved however.

It seems that most beginners' problems are less those of technique than of perception, and you should therefore be more concerned with your basic *attitude* to painting.

Choice of subject

'We see nothing truly till we understand it' (John Constable). Select a subject which you find interesting and preferably one which is well known to you. Get the feel of it, walk about in it if you can.

Consciously identify the characteristics. Enumerate them to yourself: levels – contours – distances involved – types of growth, or structure – buildings, if any, and their scale.

Study the light: the quality of the light – how it reveals the subject – the direction and altitude of the sun – time of day – weather conditions – direction of wind – movement of clouds. All these factors have probably had an influence, conscious or otherwise, on your choice of subject.

What is the dominant aspect? What do you wish to express? An idea may strike you immediately, or it may develop slowly, growing and changing. What are the essentials for realizing the idea? Does your subject depend upon a particular time of day or quality of light? (It probably does). If so, which and to what extent? What are the essential forms and grouping of masses? What is irrelevant to your idea?

Consider colour. Is there a scheme of colour? Or a dominant key of colour? For example, the subject may be essentially warm, or cold, or a mixture of both. What are the dominant colours and the subordinate colours, and what is the proportion of one to the other?

Some basic advice

1. Prepare your paper in advance.
2. Bearing in mind the overall scale and size of work-ing, you then consider an appropriate shape. Do not use just any proportion; develop the composition.
3. Select a range of appropriate colours.
4. Concentrate on the overall simple idea. See the minor forms in relation to the major.
5. Use what you find in the subject. Do not try to decorate the subject.
6. Stop as soon as you have said what you want to say in your painting.

Equipment

Keep your equipment simple and light to carry. What you use eventually will depend largely on personal choice and circumstance. Here are some suggestions for outdoor painting equipment:
1. An easel which will hold a board almost horizontally.
2. Paper stretched in advance on smallish boards (off-cuts may be purchased from a wood store or a do-it-yourself shop).
3. A carefully selected range of colours, preferably in a box with large mixing palettes. If this is not possible, white enamelled or china plates make good substitutes.
4. A few good quality brushes.
5. A small sponge.
6. An adequate supply of clean water, and water pot.
7. A generous supply of clean rag.
8. Drawing materials.
9. A notebook.

Special techniques

Before using the following techniques, you should try them out first to make sure that you are comfortable when working with the methods and materials. Used with discretion, they can greatly enhance your painting. The first two are wet-in-wet and drybrush. These are in fact basic techniques which you will need to master along with wash and colour control.

Wet-in-wet can be learned in a simple exercise which is fun to do. Wet your paper with a pale wash, and then place a brushful of darker colour on top before it dries. The second colour will run and dissolve in blurred hazy outlines into the wash. As you practise, you will learn how to control the outcome. Used heavy-handedly wet-in-wet can produce a soggy mess. You have to remember that the wetter the first wash, the more the second colour will run.

Drybrush is useful for conveying detail and supplying textural interest. You do not use the brush dry, of course, but neither is it loaded with colour. It should be barely moist. Hold the brush at a low angle to the surface of the paper and skim over it lightly. The paint should just touch the ridges on the irregular surface of the paper. The rougher the surface of the paper you are using, the more effective this technique is.

Use masking fluid for fine lines and small areas that are too tiny to paint around. Apply it with a fine brush, a dip pen, or even the end of a knife. Always wash your brush immediately after using masking fluid, as it sets quite quickly. After the paint is dry, remove the masking fluid with a soft eraser or your finger.

Keep a pan of ox gall in your paint box to produce an interesting effect with foliage or clouds. Both sponge and tissue can be used to absorb excess water from a wash, or to lift out larger areas of colour. You can apply a flat wash with a sponge rather than with a brush, but this takes practice.

To create a random, stippled effect load an old toothbrush with paint and then pull a comb through the bristles so that the paint splatters on the picture. Exercise *great* care when doing this.

Use an eraser to lighten an area that is too dark. Make sure the paint is thoroughly dry before you try this.

To create fine highlights on a nearly finished painting, scratch the surface of the paper with the tip of a sharp knife or use a razor blade. Do this when the paint is thoroughly dry.

Use the wooden end of a fine sable brush to mark lines into a wash. This technique is useful for producing blades of grass in the foreground of a picture.

A chapter explaining how to use these and other techniques in working painting is included later in the book.

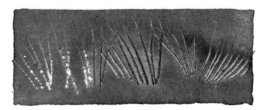

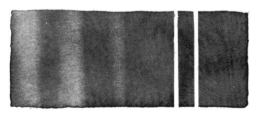

Top left: Ox gall applied in the left-hand corner makes paint disperse dramatically

Bottom left: Highlights created by rubbing away paint with a soft eraser, and cutting away thin strips of the paper surface with a sharp knife.

Above: Scratches made with the point of a sharp knife before the paint has completely dried.

Landscape
by Leslie Worth & Jan Burridge

Introduction

Watercolour landscape painting was brought to its peak in England during the eighteenth century. This was the medium most suitable for capturing the fleeting, subtle tones and colour nuances of the English countryside. Some of the finest exponents of watercolour flourished during this period, among them Bonington, Cozens, de Wint, Girtin, Crome and Cotman, to name but a few. Constable also produced beautiful watercolour landscapes, although his preferred medium was oils.

It was Turner, however, who explored the subject of watercolour landscape with greatest genius, and he produced some large-scale and complex works in the medium. He is renowned, of course, for his radiant studies of Venice, shimmering in veils of translucent washes which are transparent and misty at the same time!

It will help you enormously to study the landscapes of any of these painters, either in galleries or books. Also, do not forget that later artists like Cezanne, Dufy and Klee used watercolour brilliantly; and that the genre is becoming increasingly popular nowadays with young painters.

As a subject landscape provides great pleasure. The countryside is a vital, ever-changing element. The wind will cause grass to ripple and trees to bend; clouds will scud across the sky and change the light – and you will soon be aware that the landscape you started early in the morning can look entirely different by late afternoon!

The following demonstration paintings and commentaries by Leslie Worth and Jan Burridge show the wide scope of the subject, ranging from basic elements such as trees, water, buildings and clouds to more complex compositions and combinations.

Elements of Landscape
Trees and foliage

Commentary and paintings by Leslie Worth

The painting of trees and foliage presents the painter with some of the most difficult problems in watercolour. The subjects are almost always complicated and the inexperienced painter may well be overwhelmed by the profusion of detail and at a loss to know how to represent it. I have vivid memories of trying to cope with these problems, and although my solutions have not always been successful, here are some observations which may be useful.

Choice of subject

At first, choose subjects which are lit in a lowish cross light – early evening may be the best time. This will simplify the leaf masses for you, and make for easier comprehension.

Select a subject at some distance so that the grouping is simplified. (Corot often adopted this device; he also used to view his subjects in a fading light when the forms were simplified.)

Tactics

It may be helpful to make a small drawing beforehand, to explore the problem and attempt to organize the complexities in your own mind before putting brush to paper.

For your painting, choose a paper of moderate weight and surface, not too absorbent. Stretch it in advance and do not apply the colour washes too wet or control will be difficult.

Observe that in a subject well defined in masses of light and dark, the tones within the light areas must remain light, and in the darker areas relatively darker. Do not allow them to intrude on each other.

Notice too the subtle but considerable modification of colour within any given area.

Remember that your brush is a *drawing* instrument and the individual marks you make must shape the volumes you are describing.

Demonstration (*overleaf*)

This watercolour was painted at the edge of a park over two mornings in late March. They were days of bright sunshine, relatively warm, with a light breeze blowing.

Stage 1

Stage 2

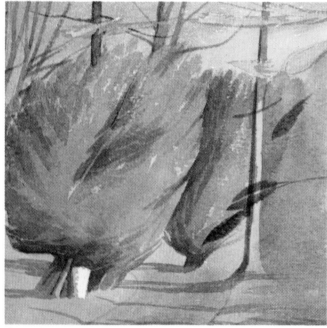

Stage 3

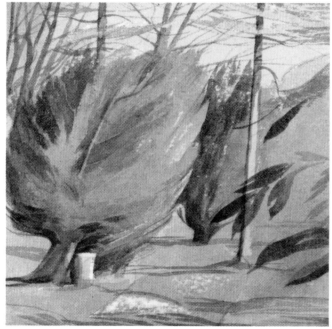

Stage 4

I made a drawing in order to sort out some of the elements of the subject. It consisted essentially of a large, rather ragged box tree and a darker, more formal yew. These solid forms contrasted with the more linear shapes of the larches and beeches beyond, and certain accents of interest in the laurel leaves and other details.

Demonstration

Size: 170 × 170 mm/6¾ × 6¾ in. Paper: Arches 135 gsm/90 lb. Brushes: 00,7,10 sable. Time taken: 4 hours.

24

Stage 1

The complexity of the subject calls for some preliminary guidelines. Indicate the placing of the main proportions of the trees and path with a light pencil drawing. Brush a wash over the drawing to indicate the principal colours of sky and trees. Keep edges soft by painting wet-into-wet (but not *too* wet). Leave light foliage areas as blank paper. This stage should indicate the overall mood of the painting.

Trees and foliage demonstration

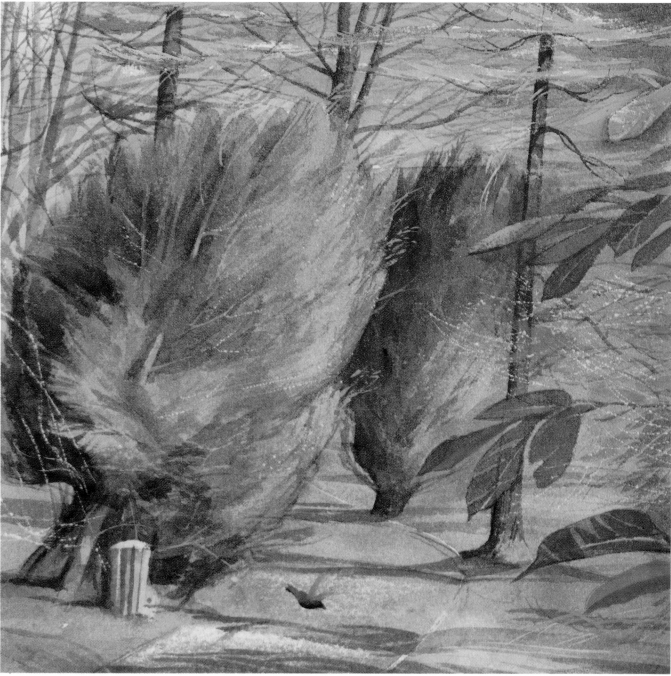

Stage 5 — the finished painting

Stage 2

When the first stage is quite dry, pick out the main masses of the subject. Using rather muted values and following the direction of the light, give the trees volume. The colour in the shadow areas inclines to violet, and the warm golden light areas complement this. Indicate cast shadows across the ground. These help to give depth to the study, as does the dark accent of the laurel leaf in the foreground. Colours used: cadmium yellow, raw sienna, light red, Prussian blue, indigo, cobalt violet.

Stage 3

Indicate the branches of the trees in the distance. Add more detail to the large box tree in the foreground, concentrating on the description of the shadows of the leaf masses. Strengthen the colour throughout where necessary.

Stage 4

Strengthen the indications of the background trees. Introduce greater depth of colour into the shadow areas. Develop the finer details of the box tree and the

yew and build up the shadow surrounding the yew to pick out the light trunk. Paint in the laurel leaves in the foreground. Use a sharp knife to lift off areas of broken light on the path.

Stage 5 (*previous page*)

The finished painting. Using a fine brush, add detail to the foliage. Pick out the pale stems of the foliage with a sharp knife. Strengthen the colour washes overall. The blackbird flying across the path was introduced to give some movement in the painting.

I have reservations about the success of this painting. The background is not sufficiently mysterious, and the laurel leaves lack intensity.

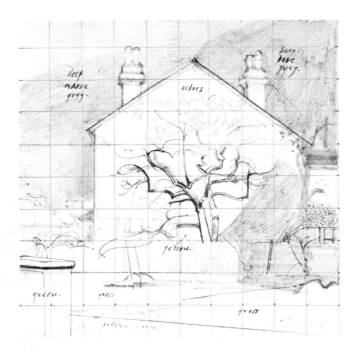

A working drawing. Colour values have been noted on the drawing as the quality of winter light changes so rapidly. In the final painting (page 28) a dark tree has been added on the left, and other adjustments made to give balance. Time taken, two hours.

Buildings

Commentary and paintings by Leslie Worth

Because of their infinite variety of shape, colour and texture, buildings of all sorts provide a rich fund of painting experience. I would advise that you begin with something simple, but which nevertheless has an attraction for you.

You will be concerned with representing the structure of the subject, so your powers of draughtmanship will be put to the test, and the basic principles of perspective will be involved.

In painting a building there are two aspects to be considered. First is that of representing the building in its true proportions and scale in relation to its surroundings; this may be thought of as the *drawing* aspect. Secondly, there is the relationship of colour, texture, light and the sheer material presence of the subject – the *painting* of it. In practice, of course, these two aspects are indivisible.

Demonstration

Size: 170 × 170 mm/6¾ × 6¾ in. Paper: Arches 135 gsm/90 lb. Brushes: 00,7,10 sable. Time taken: 3 hours.

Notes on the demonstration painting

For the purpose of demonstration I selected a fairly simple subject, the end gable of a cottage which stands in a terrace.

The time was between 11.00 a.m. and 12.30 p.m. on a late February day. The weather was mild but threatening rain, the sun strong and lying to the right; heavy grey clouds forming ahead made a dramatic foil to the ochre stuccoed surface of the cottage. The solid sombre elevation contrasted with the delicate linear tracery of the apple tree, and an interesting variation was introduced by the angular shadows cast by a building to the right of the picture.

I made a drawing on the spot of the subject and carried out the painting from the information conveyed in the drawing.

Essentially the colour structure is a simple complementary scheme of yellow/violet with a minor red/green counterpart in the fencing and foreground grass. The colours are muted, the yellow being ochre and the violet a soft dove-grey.

Buildings demonstration

Stage 1

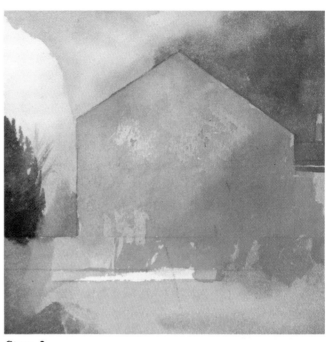

Stage 2

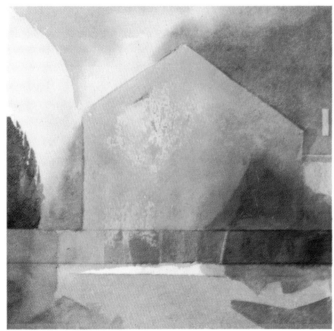

Stage 3

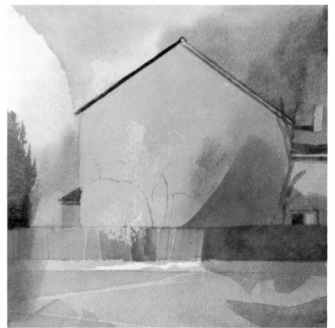

Stage 4

Stage 1

Make a light pencil drawing of the structure and brush over it washes based on the lightest dominant colour value. Treat the washes freely and allow the maximum unity of lighting overall and between sky and ground. There should be a suggestion of the final balance of warm to cool areas within the scheme of complementary colours at this stage. Try to establish the general mood and key of the painting at the outset. Colours used: raw sienna, chrome orange, indigo and monestial blue.

Stage 2

Complete the sky passages at this stage in order to preserve freshness of execution. Put in the dark accent of the yew tree on the left; this is valuable to give a key to some of the middle passages of colour. Paint in the principal colour values of the stuccoed gable, putting in the lighter, flaking area in the centre with a drv brush. Brush in the darker, cooler areas towards the bottom left while the paper is still damp. Be careful not to get the colours too heavy or jumpy at this stage.

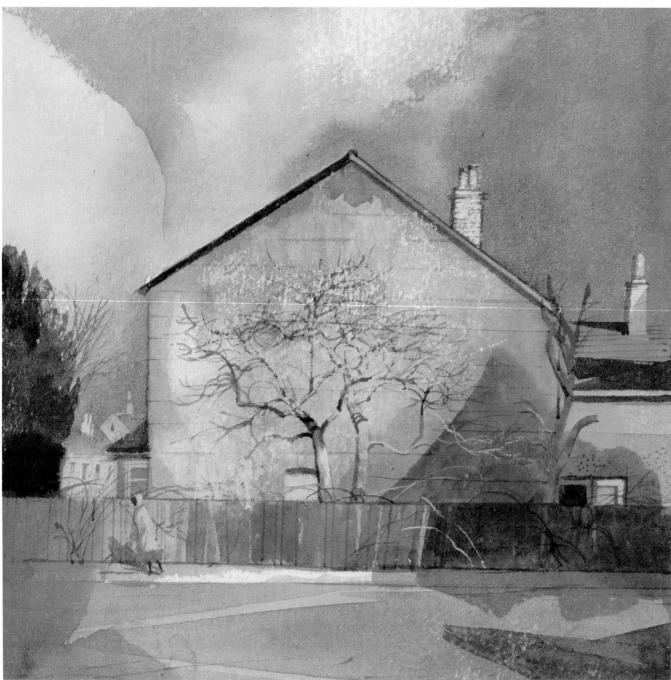

Stage 5 — the finished painting

Stage 3

Paint in the shapes of the cast shadows on the right and strengthen the colours in the fence, linking together the right and left sides of the painting. It is important at this point to bind together the large elements of the design, and so avoid fragmentation of the idea.

Stage 4

Introduce details such as the roof, the fencing and the apple tree. These accents of interest set the key for the

degree of realism in the painting which will be governed largely by personal choice and ability.

Stage 5

The completion of the painting. Add the architectural details, chimneys and so on, taking care to keep them in scale with the rest of the painting and to avoid fussiness. Finally, look over the work as a whole, pulling together the colour washes and strengthening or subduing where necessary.

Water

Commentary and paintings by Leslie Worth

The painting of water in various forms is one of the most attractive subjects for the watercolourist. Its translucency, limpidity and changing mood allow the painter to exploit watercolour to the maximum. Of course, hand in hand with the beguiling charm go the difficulties, so to start with choose a relatively uncomplicated subject.

The subject

The time was mid to late afternoon early in March, a day of strong wind, bringing a changing pattern of brilliant sun and short, heavy rain showers. The painting was done entirely on the spot, the location is a large pond surrounded on three sides by dark woods of silver birch, oak and ash. Soft, smudgy, warm bands of colour lie across the pond where the reeds and bulrushes grow. The muted light and dark clouds and subdued blue of the sky are reflected in the pond and the surface is disturbed now and again when the wind, darting through a gap in the birches, ruffles the surface. The dark mass of the distant woods and dazzling light reflection in the foreground make an extreme contrast.

I found that I could paint the subject using only three colours: indigo, light red and chrome orange. I have some reservations about the orange. I like it, but it is very strong and can be treacherous. I used two sable brushes, a no. 10 and a no. 7. Both were springy with good points, so it was possible to paint very fine detail, such as the stems of the bulrushes, even with the larger brush.

Notes on the demonstration painting (*pages 30–1*)

As a demonstration I chose to paint part of a pond, and this posed quite sufficient problems, with its varying depth of colour and translucency, its surface smooth yet broken by reeds and ripples, ruffled by the wind and disturbed by a coot. A further complication was the low wintry sun directly overhead, which made a brilliant reflection in the left foreground. Technically, this subject raised the problems of painting isolated light areas within dark ones, and of painting wet-into-wet while introducing dry strokes, graduated washes and sharp detail. In fact it presented most of the technical difficulties encountered in watercolour painting.

Demonstration

Size: 170 × 170 mm/6¾ × 6¾ in. Paper: TH Saunders 135 gsm/90 lb. Brushes: 7,10 sable. Time taken: 2½ hours.

Stage 1 (*page 30*)

With this subject the most important thing is to establish *at once* the mood, character of lighting and essential unity. Basically it is a cool, dark subject, shot through with warmer passages (reeds) and with a brilliant contrasting burst of light in the reflection of the sun.

First damp the paper slightly all over, except for the small light area in the sky, top left, and the light reflection below. Starting at the top, brush in a cool wash, making subtle shifts of colour (for the reeds, reflections and so on) as you move down the paper.

Stage 2

At this stage some form must be introduced into the painting and the geography of the subject defined a little more. Introduce lighter reflections into the water in the foreground by gently pushing a folded piece of clean rag on to the painting while the wash is still damp. You had better practice this on a spare piece of paper beforehand, as it is a slightly tricky operation.

When the paper is dry, the wood in shadow at the far end of the pond can be given shape. Take a darker, warmer wash of colour (indigo + light red) down the area, shaping the contours of the trees and carefully steering round the pale trunks of the silver birches on the right. Use the same dark wash to indicate the slim dark bands of water in the distance.

Stage 3

I found it necessary to strengthen the tones in the water at this stage, and you may well find that you need to do this too. If you do, make sure that the paper is dry beforehand, or ugly bleached areas will appear. Then damp the paper with a brush and clean water and float on the stronger colour, swiftly, with as little disturbance of the surface as possible. This may sound paradoxical,

Stage 1

Stage 2

Stage 3

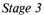

Stage 4

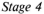

but as a general rule it is much safer to allow one wash to dry, then damp the surface and work into it again. If you don't believe me, try it and see!

Paint in the reeds and bulrushes, allowing the stems to vanish into a damp area below, so that they are kept well back in the picture.

Stage 4

Now you are almost ready to paint the rippled surface of the water. But first examine the water surface carefully to discover what is happening. You will notice that a pattern emerges. There are deeper, bigger movements of the surface, on top of which are minor, more agitated ripples, and these movements have a rhythmic interplay. Always base your work on sound observation.

Then pick out the light streaks in the water. Use a sharp knife sparingly to do this.

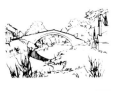

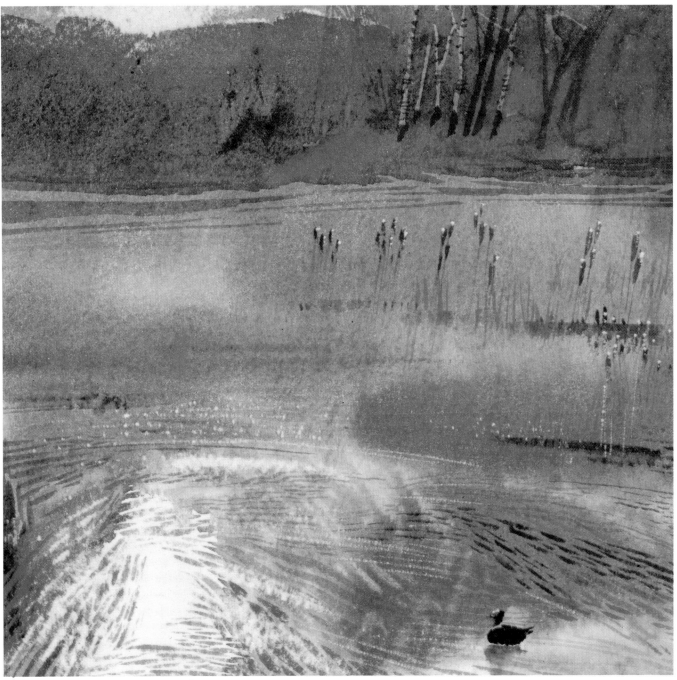

Stage 5 — the finished painting

Stage 5

There is really no break between this stage, the completion of the painting, and the preceding stage. The overall purpose here is to bind together the elements of the painting.

Strengthen the dark indigo reflection in the right foreground of the pond. To depict the light breaking over the distant trees, take a sharp blade across the area, lifting out the wash, and allowing a fine line to skim the edge of the trees. Also use the knife to pick out light accents on the heads of the bulrushes and some of the sharper ripples in the foreground reflections.

Cumulus cloud study

Commentary and paintings by Leslie Worth

Skies and cloud formations offer endless interest to painters and also present many difficulties. The complexities and subtleties of ever-changing light, colour and form tax a painter's resources and are particularly well-suited to watercolour. To do the subject justice, an understanding of cloud and skies is almost essential.

It is not possible to cover in depth the complexities of painting skies in this section, so I hope wider application can be drawn from the principles illustrated by this particularly lovely cumulus cloud.

Degas said 'When I want to paint a cloud, I crumple my pocket handkerchief and hold it up to the light!' This is rather a good idea, because success depends to a great extent on close observation of light falling on an accumulation of billowy masses. Other clouds moving across the main mass are seen as dark forms against the light, reflective surface of the cloud behind.

It is necessary to discover which cloud formation is involved, where the light is coming from and what direction the clouds are moving in. Do *not* try to copy it, try to understand it. Remember that clouds are basically light masses and that even the darkest areas are light. Working into damp paper will yield soft tones, and if you want a sharp edge, paint on a *dry* surface.

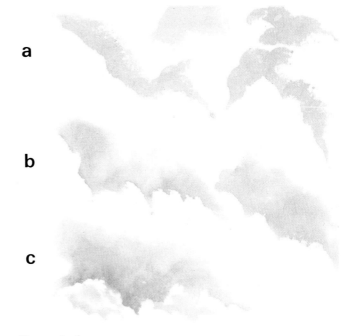

Example 1

Example 1

These are characteristic brush marks used in *Cumulus cloud study*.
a. Direct brush marks on a dry surface.
b. Paint the upper edge on to a damp surface and the lower extremity of the tones on to dry paper.
c. Add more tones to existing ones while the colours are still damp. Try not to soften the hard edges too much or the cloud will lose its form.

Demonstration

Stage 1

This drawing indicates the general directions from which light falls on the cloud masses. Compare this sketch with stage 4 (page 34) to understand this. Always study the subject carefully before committing brush to paper.

Cumulus cloud study demonstration

Stage 1

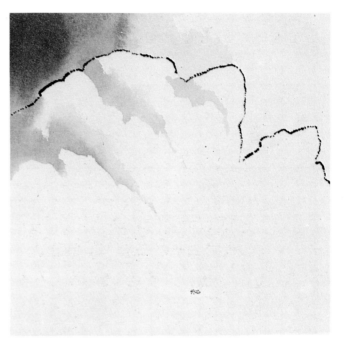

Stage 2

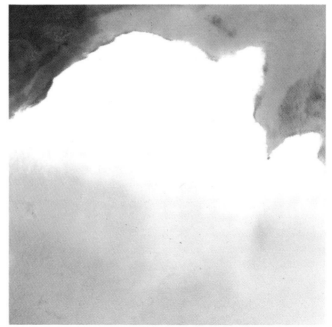

Stage 2

This diagram shows soft shadow in the cloud crevices. To turn the masses into soft shadow, damp the edge at the top of the mass which enables you to add tone without a hard edge.

Stage 3

These are the first stages of *Cumulus cloud study*. Dark lowering sky surrounds the brightly lit 'thunderhead'. This stage defines just the area and outlines the shape. Paint the grey background against a dry edge and paint the lower clouds as a wash on a slightly damp ground to keep the forms soft.

Stage 3

Cumulus cloud study demonstration

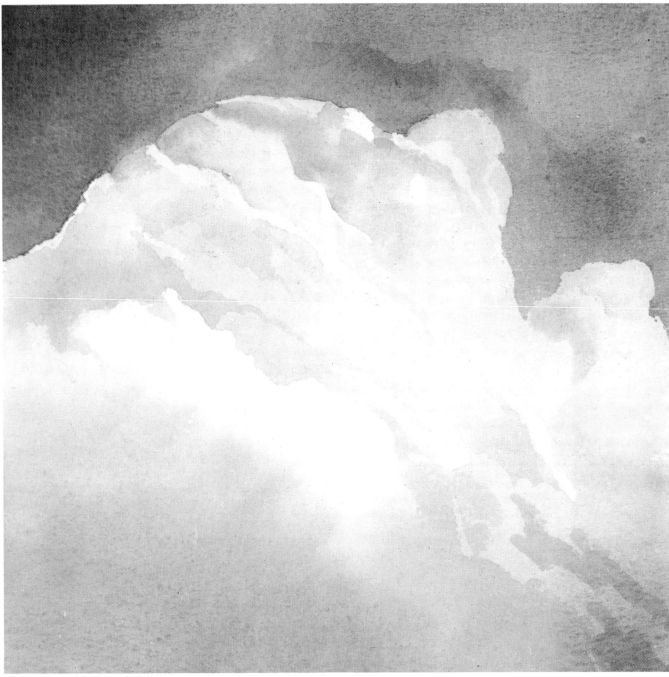

Stage 4 – Cumulus cloud study

Stage 4

By carefully applying the techniques in example 1 to stage 3 you should be able to give modelling and mass to the cumulus cloud. The most important point to remember when painting clouds is to use as little pigment as possible in a wash. Clouds are masses of light and need only the softest shadows and dark areas.

Landscape

Commentary and paintings by Leslie Worth

This watercolour (pages 36–7) was painted on the edge of the Surrey Downs, looking north-west. It was a light, fresh morning early in March, with a cold westerly wind blowing (from the left to the right of the picture), a fair amount of cumulus cloud building up and some hint of rain to come.

Basis of the painting

I was attracted by the quality of silvery light over the landscape, sharp but subtle in colour, and the sparkle of accents in the conifers and houses in the middle distance.

The painting operates on a simple structure of contrasting, complementary colours. The field and foreground are basically warm yellows, containing raw sienna, chrome orange, monestial blue, violet. The cool sky and distance are basically blues, and contain indigo, monestial blue, light red and violet.

Note that in the colour mixes, each colour division contains elements of the opposite (complementary) colour value as a qualifying ingredient. For example, in the field and foreground (warm) sienna and orange, the dominant colours, are modified by blue and violet.

The middle distance

The trees and houses in the middle distance provide the main subject interest. Here the colours are a mixture of warm and cool elements and, colourwise, lie between the main divisions of yellow/blue, ground/sky. The colour mixes (from the colours listed above) are subtle and close in value, relieved only by the dark accents of the conifers and the light forms of the horses in the far field.

The sky passages

Even on a clear day, the sky is rarely a flat blue. The presence of vapour, the inclination of the sun, and so on, introduce changes from top to bottom, left to right, according to time of day, weather conditions, and the position of the observer. It is very important to be aware of the mood of the sky, as this will determine the character of the landscape.

Notice that the strongest colour in the sky is overhead. The colour becomes progressively fainter as the atmosphere thickens towards the horizon. Dust, smoke, moisture, and so forth, will also bring about changes in the light and a general opacity.

Demonstration

Size: 170 × 170 mm/6¾ × 6¾ in. Paper: Arches 135 gsm/90 lb. Brushes: 00,7,10 sable. Time taken: 3 hours.

Stage 1 (overleaf)

The first step is to establish the overall mood of the painting, through the chosen range of colour and lighting. This requires careful rehearsing of the presentation and selection within the subject in your mind before you commit brush to paper. Make a sketch or do a working drawing to clarify your ideas. It may be too late to change anything drastically afterwards, although some modification may be possible. Notice that at this stage the sky is almost fully realized and only minor details are added later. Although the main divisions of sky, distance and foreground are stated, there are no hard edges. To achieve this effect, damp the paper all over, except for the lightest part of the cloud. Do not get the paper too wet, or it will be difficult to control. Mix enough colour on your palette to cover the chosen area. Work from the top of the paper down. Allow this stage to dry completely before proceeding to the next.

Stage 2

The aim here is to qualify the sky a little more and to indicate the far distance. Damp the sky area above the cloud with a sponge or clean brush. Then introduce a little stronger blue into the sky and stronger, darker colours into the cloud mass, to give it more fullness.

Now paint in the high ground in the distance. Damp

Landscape demonstration

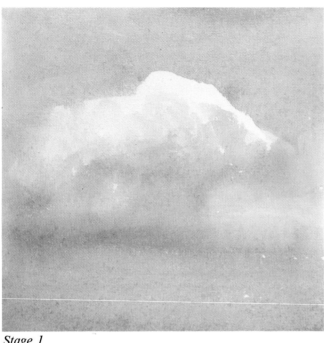

Stage 1

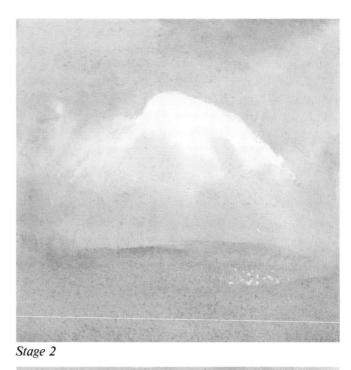

Stage 2

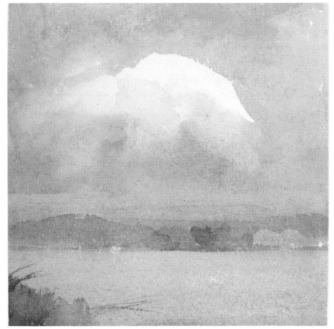

Stage 3

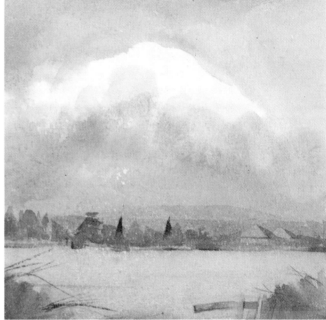

Stage 4

the paper to the left and right of the cloud mass and then take the colour across the paper. This will give a slightly sharper line in the centre.'

Stage 3

Brush in the darker masses of trees in the middle and far distance, isolating the forms of the two houses on the right. Add the foliage mass in the left foreground. Keep the tones subtle and damp the paper in advance where necessary.

Stage 4

Add the sharper accents of the conifers and houses in the middle distance. Damp the paper beneath the conifers before painting them in, so that the trees rise gently from the ground. Isolate the lighter accents of distant walls and fences by painting darker tones around them. Add shadows gently where necessary.

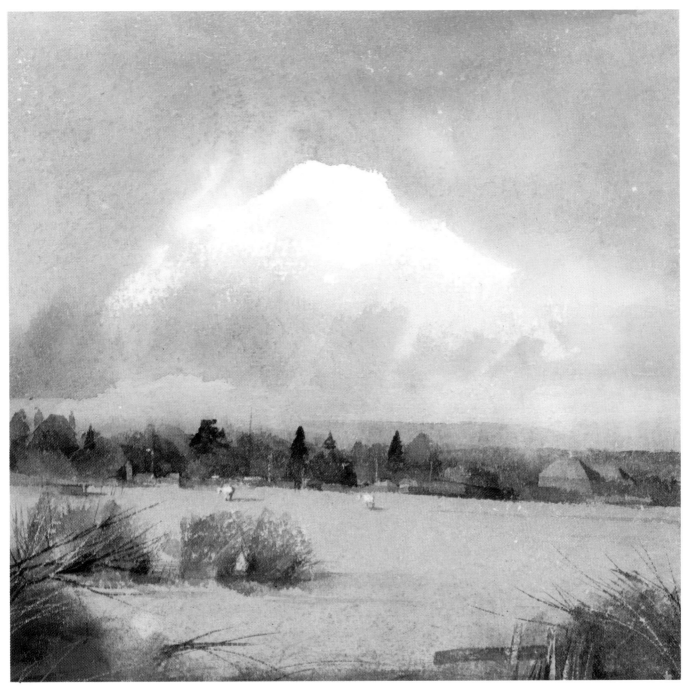

Stage 5 — the finished painting

Stage 5

The completion of the painting and the moment of truth. Most of the work has been done and little needs to be added. But what remains is critical. Look over the whole of the painting and consider it. Do not regard this stage merely as an opportunity to add extra detail, but endeavour to bind together the whole, suppressing anything which is disruptive and strengthening weak passages. The small details we love to include will then serve to emphasize the breadth of the whole painting.

Add the line of rushes in the near foreground and, using the tip of a sharp blade, pick out the forms of the horses in the field, the light accents of distant lamp-posts and the bare twigs in the foreground.

Stage 1

Stage 2

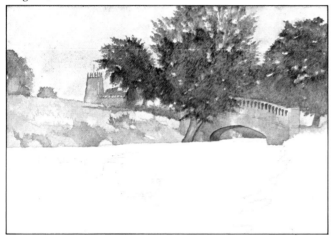

Stage 3

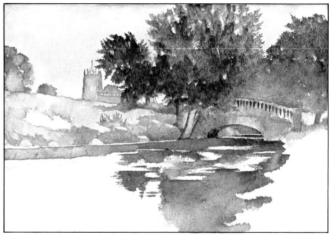

Stage 4

On a summer's day

Commentary and paintings by Jan Burridge

A landscape in warm summer sunshine under a clear bright sky is a very attractive subject for watercolour painting. The light reflected from the surroundings produces vivid colours, and deep contrasting shadows result in bold lines within the watercolour. Although these conditions are most attractive, they are not necessarily the easiest to reproduce in watercolour as you need experience to handle rich colours and strong shapes sensitively. I painted the landscape shown on page 39 on a glorious late summer afternoon. The trees were just beginning to show a hint of magnificent autumn shades; the grass was thick and rich in colour; and the river was dark and deep under the trees but bright with reflected light in the open.

I was sitting on a river bank looking downstream. The sun was slightly to the right in front of me and glinting through foliage which shaded me from its bright light. The sky was cloudless and the sunlight very strong, giving intense contrast between areas of light reflected by the water on my left and the grassy slopes of the far bank and the deep shadows under the

trees and bridge. The church tower appeared as a soft shadow against the sky to the left of the trees above the other bank.

Demonstration

Size: 353 × 253 mm/14 × 10 in. Paper: Bockingford 285 gsm/140 lb. Brushes: 0, 1, 2 sable.

Stage 1

Before painting, make a sketch to establish the correct proportions of the features in the watercolour. You can also use this drawing to isolate areas of dark and light tone and to make pencil notes on colour strengths. When painting I prefer to finish one area at a time. With a subject like this, I usually begin with the sky.

Make a very fine pencil drawing to isolate the sky shapes against the watercolour. Wet the sky area and put in washes in different shades of French ultramarine, cobalt green and yellow ochre. Remember that a wash always dries paler so allow for it at this stage. The results are never satisfactory if you go over a wash once it has been allowed to dry. While the wash is still wet, add a little more yellow ochre around the outline of

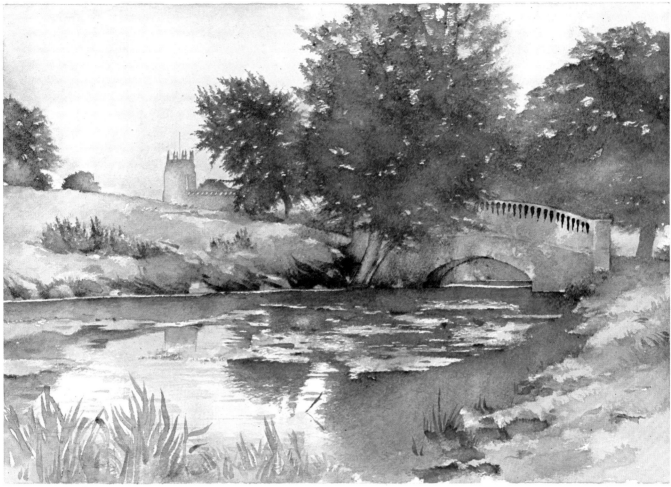

Stage 5 - the finished painting

the trees to indicate the powerful sunlight coming from behind the leaves.

Mix a thin wash of Prussian blue, crimson lake and sepia, and paint in the silhouette of the church. Distance and shadow combine to conceal all architectural details on the church except for a row of parapets that catch the angle of the sun along the roof. Highlight these with yellow ochre. Let the sky and the church dry completely.

Stage 2

Begin painting the brightly-lit grass on the far bank by laying in a wash of sap green, hooker's green and raw umber. Do not let these three colours intermix too much or the subtle changes in colour will be indistinct. Insert the trees on the left with a mixture of sap green, sepia and Prussian blue. Give warmth to the turning copper beech leaves on the tree to the right of the church with a mixture of sepia, burnt umber and crimson lake. Use some drybrush here to give harder edges and suggest branches and finer detail.

Stage 3

Paint the tree at the water's edge with a mixture of sepia, sap green and burnt sienna. Use the same mix-

ture with a touch of Prussian blue for foliage on the tree on the right. Use wet-into-wet and drybrush on these trees to obtain differing textures and hard and soft edges to the foliage. The trunks of these two trees call for differing approaches: the tree at the water's edge has darker lines down the side of the trunk which make it far more prominent than the trunk of the right-hand tree.

Use a pale wash of sepia and raw umber for the bridge. Let this wash dry before adding more shadows and architectural details with a mixture of crimson lake and Prussian blue.

Stage 4

The dark areas of water below the bridge reflect the tree and bank beside it. Use the same colours (sap green, hooker's green, raw umber, sepia and Prussian blue) to lay in the darkest areas on the surface of the water. A few horizontal brushstrokes will give distance to the water.

Stage 5

When these colours are dry, use raw umber and sap green and some drybrush to show the weed and lilies

39

floating on the river. Some remaining areas of white paper give the effect of broken reflected light. Put in thin washes of sap green and hooker's green for the grassy bank on the right and lay secondary washes of wet-into-wet into this to give darker areas of grass. Use these colours for the reeds in the foreground and add dead vegetation in sepia and raw umber, and a little Prussian blue for the shadows. Wet the lightest area of the river and put in an extremely pale wash of cobalt blue; add a few reflection details to this water surface. Use drybrush for the sharper details and wet-into-wet for soft dark shadowy areas.

Gloomy weather

Commentary and paintings by Jan Burridge

Washes that diffuse too widely into one another or develop an overall evenness of tone quickly destroy the freshness and light of a painting.

Practise wash control so that you can predict the flow pattern of pigment as brushwork dries. Opposite are a few simple demonstrations which you can practise and which will also help paint "Gloomy Weather".

Example 1

Use a flat brush to produce a stroke of colour on dry paper; with a clean brush immediately add three strokes of water on the right-hand side. Watch how the colour is carried across the entire area as it dries.

Example 2

Paint three strokes of water with a clean brush and add one stroke of colour to the right of these. Look at the difference between the results and those of example 1.

Example 3

Paint three strokes of clear water and then put one brushstroke of colour in the middle of these three strokes. Watch the paint disperse softly, leaving no hard edges within the wash area. These three basic tests help you to predict the flow of colour across a sky or a large wash area. With care and practice, you can judge the right softness or colour accent to define the edges of cloud banks for large, even-toned landscape areas.

Example 4

Take a large, pointed sable brush and make a single stroke of colour. Wash the brush and add a brush-load of clean water to the stroke; study the result.

Example 5

This is the reverse of example 4. Make a stroke on the paper with clean water and then add a brush loaded with paint to this clear brushstroke. Notice that the colour is richest at the centre of the mark and lightest at the edge.

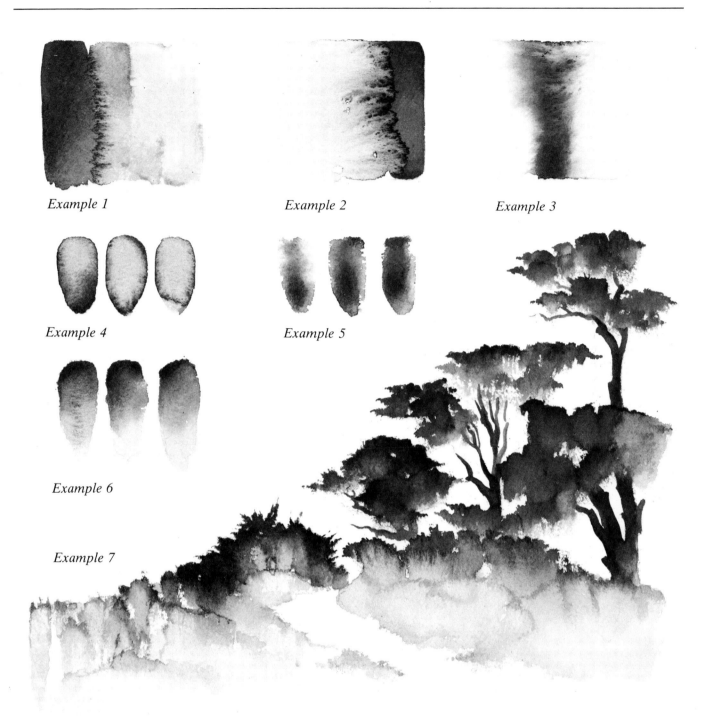

Example 1

Example 2

Example 3

Example 4

Example 5

Example 6

Example 7

Example 6

Load your brush with water and dip the tip in pigment before making a stroke on the paper, so that you push the main concentration of colour towards the top of the stroke. This technique is very useful for trees and grasses, as in example 7.

Demonstration

Size: 265 × 215 mm/10½ × 8½ in. Brushes: 0, 1, 2 sable. Paper: Bockingford 285 gms/140 lb.

I was going for a walk on an extremely wet summer's day when I came across this view. The sky was very heavy and a light rain was falling. The sun was beginning to break through the clouds far out to sea, giving a dramatic light effect.

Gloomy weather demonstration

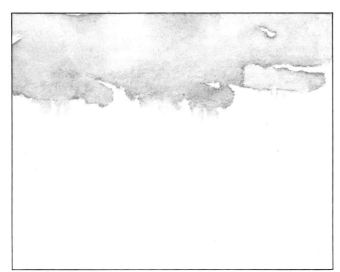

Stage 1

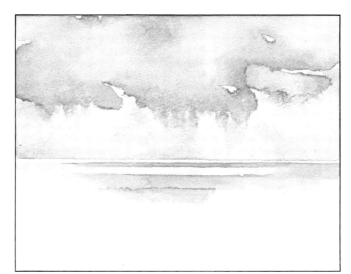

Stage 2

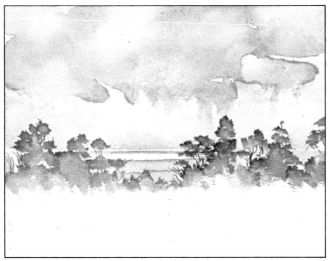

Stage 3

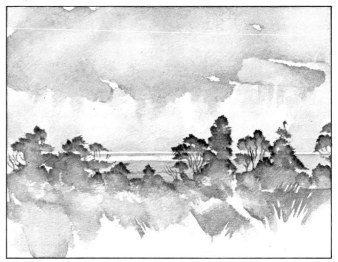

Stage 4

Each stage has been isolated for the purposes of this demonstration. However, with a painting that has as many soft-edged washes as this, you should maintain a continuous flow of work. In this way washes merge with one another when still wet and create an overall impression of softness and dampness in the air. If each wash is allowed to dry separately, hard lines of colour appear at the edges and the more subtle muted effects are destroyed. This painting took me thirty-five minutes from start to finish.

Stage 1

Wash in the heavy cloud with a mixture of Prussian blue and crimson, using a wide flat-wash brush. Keep the lower edges of this wash wet to allow the paint to merge with the clouds in the distance.

Stage 2

Paint in the distant clouds with a broken wash made up of ultramarine, turquoise and yellow ochre.

Although there is a lot of water on the paper at this stage, keep to a hard-edge horizontal line for the horizon; do not make all the cloud edges soft. The sea reflects the sky, so add bands of Prussian blue in the water with horizontal areas of white paper. When dry, lay a very pale wash of yellow ochre across part of these.

Stage 3

Position the line of trees in the middle distance, using sepia, burnt umber and Prussian blue. Paint these loosely on dry paper so that the tops are silhouetted sharply against the sea. Wet the lower edges to encourage the paint to merge softly with the foreground foliage in stage 4.

Stage 4

To create an impression of soft wet grass, lay in a loose broken wash of hooker's green, burnt sienna, yellow ochre and sap green.

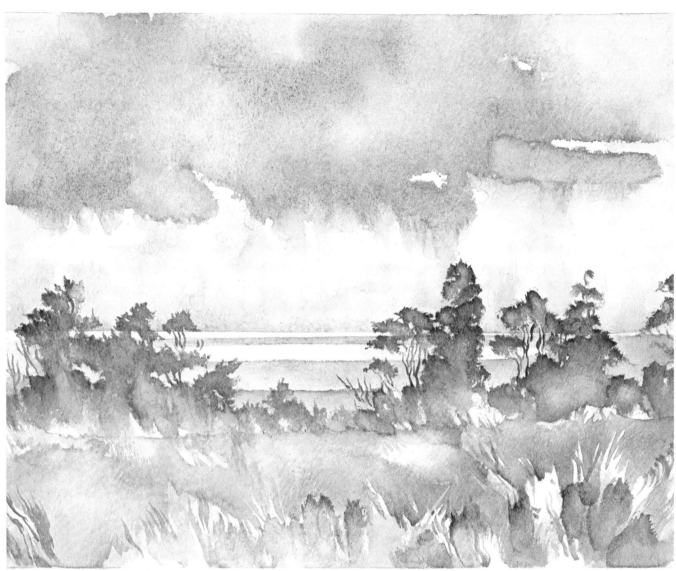

Stage 5 - the finished painting

Stage 5

To add further detail to the foreground grasses, work some pale wash lines on dry paper. The sharp edges produced make the grasses appear very close and put the trees and other vegetation further into the distance. Lift some of the colour from the trees with tissues to give a misty impression.

Beside the wall

Commentary and paintings by Jan Burridge

It is often helpful to base a landscape composition on an interesting detail, such as an attractive gate, a stone wall, a building or a fallen tree. Then you have a focal point from which the eye can travel to distant parts of the picture; this device also helps you to extend the field of focus to include individual leaves, flowers and grasses.

When planning a painting, do not make too large a jump from the focal point at the centre to the background behind, or the painting will lack harmony. Balance colour as well as composition. The nearer the focal object, the more critical its position in the painting *and* its related colour values.

Using foreground detail in composition

44

Demonstration

Size: 265 × 265 mm/10½ × 10½ in.
Brushes: 0, 1, 2, 6 sable. Paper: Bockingford 285 gsm/ 145 lb.

Stage 1

This ancient stone stile is an ideal focal feature and a natural bridge from the late evening sky behind the distant trees to the brambles in the right foreground. Wet the sky area, but not right up to the edges of all the natural subjects. Mix a wash of yellow ochre with a touch of hooker's green and draw around the edge of the wet area so that the colour spreads inwards and diffuses evenly. Let the wash dry.

Stage 2

For the golden-brown trees in the distance, paint burnt sienna and sepia in drybrush. The dark green conifers are a wash of sap green, hooker's green and sepia with lots of water. To give them varied tone, first paint the outline of each tree, then add water to the centre of the tree.

Stage 3

The wall on the left is not difficult to paint. Use a very fine brush to draw the outline of the tones in sepia. Keep the paint thin, and try to capture the shape of the stones so that they look like heavy rocks and not grey, weightless blobs. When the paint is dry, add raw umber, sepia and hooker's green in drybrush to give the effect of ancient moss and lichen.

I always mix at least two colours when painting outlines. One colour produces a flat, dull and (for landscape painting) unreal effect.

The light-grey wash used for the stile has a base of sepia with Prussian blue and crimson red added and drybrushed in places to give texture and roughness to the surface. Leave some small areas of white paper for highlights. Draw a grain on the wooden rail above the stile so that it has a different texture to the stone.

Beside the wall demonstration

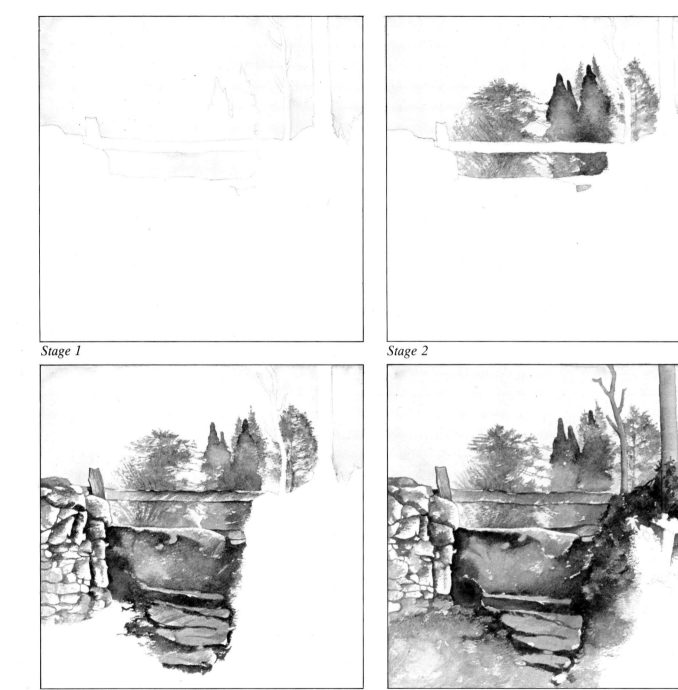

Stage 1

Stage 2

Stage 3

Stage 4

Stage 4

For the dark foliage to the right of the stile brush in sepia, hooker's green and touches of raw umber and Prussian blue. Do not push the paint around too much or it will become muddy. Let small areas dry so that hard edges give good colour variety in the area of shadow.

Use a no. 6 sable brush for the grass in the left foreground. Vary the colours: sap green, raw umber and burnt sienna, and use some drybrush to give a variety of forms.

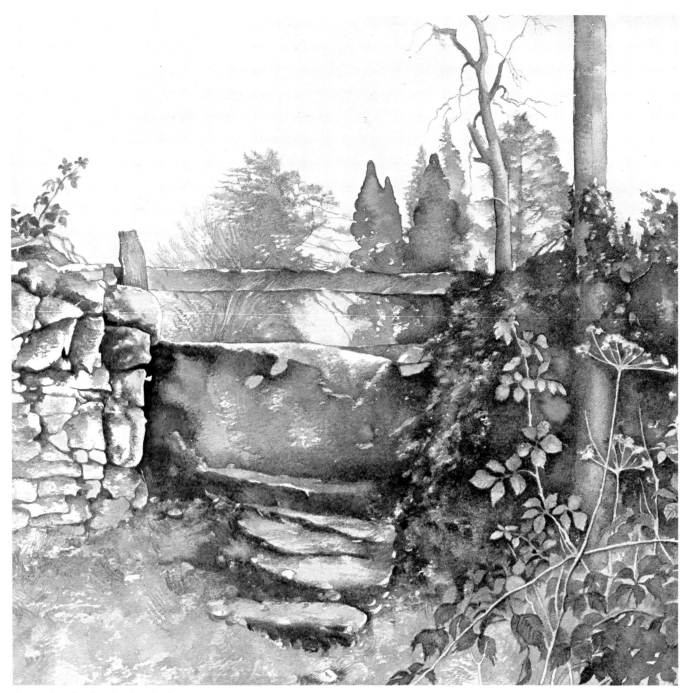

Stage 5 - the finished painting

Stage 5

Complete the vegetation and the lower tree trunk by drawing around their shapes with sepia. Take great care when doing this; study the leaves and stems so that you make the plants look like brambles and cow parsley. Take a larger sable than the one used for the basic drawing, load it with water and fade the outlines of these plants into the background so that it matches the dark foliage of stage 4. Use thin yellow ochre mixed with crimson red for the bramble stems, and mix sap and hooker's green in different proportions for the

younger leaves. Use sepia and Prussian blue for the older leaves.

If you imagine the finished painting without these close foreground details, it appears flat.

46

Stage 1

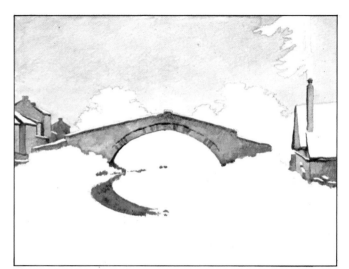
Stage 2

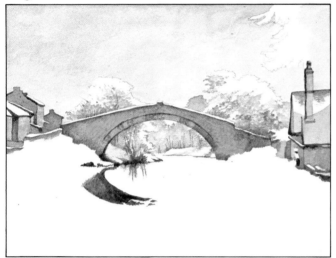
Stage 3

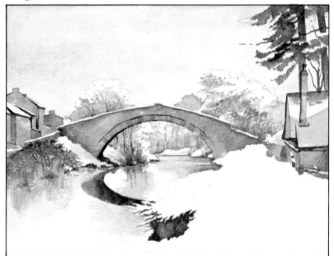
Stage 4

Light snow

Commentary and paintings by Jan Burridge

Winter, with its many transformations of light and colour, demands different techniques from painting in summer. In winter sunlight is weaker and the low angle of the rays forms long blue shadows. When stripped of their foliage, trees have fascinating outlines, particularly when they are laced with heavy frosts or a fresh fall of snow. Trunks and branches appear darker and the warm yellow-greens and golden-browns of summer foliage are gone. Winter colours are flatter and less vibrant; they are usually cold shades of blue-green and grey with a little pink in distant trees and long shadows.

In the depths of winter, the brilliant reflective surface of snow emphasizes and distorts colours and details; if the sun shines, snow produces perhaps the brightest light in the whole year. Otherwise it affords very soft, almost indiscernible variations in shadow. Leave fairly small areas of paper completely white when painting snow. Use very pale washes of colour to produce undulations on a snowy surface. After a fresh fall of snow, everything has a white top edge and you must leave space for this when painting. Snow is rarely completely white as it reflects the colour of the sky and other strong features. Very few areas are white in the finished painting on the next page.

If you are painting in the snow remember to wear plenty of warm clothing. You will soon find it too cold to work even if you are making no more than a thirty-minute sketch.

Demonstration

Size: 265 × 203 mm/10½ × 8 in.
Brushes: 0, 1, 2 sable. Paper:
Bockingford 285 gsm/140 lb.

Light snow demonstration

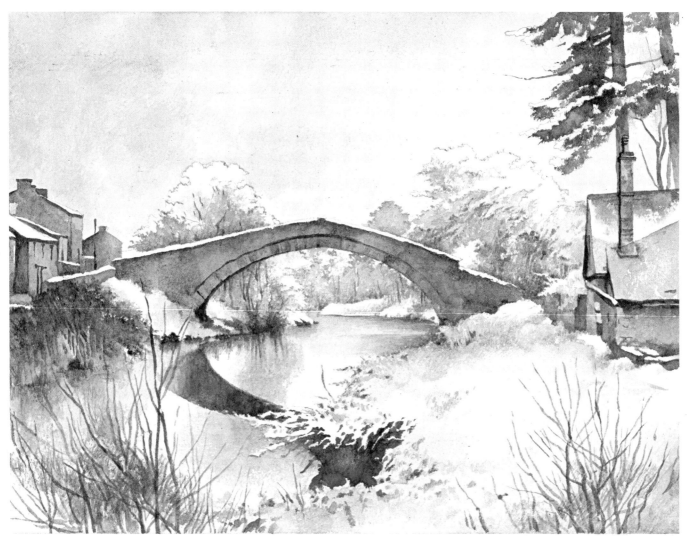

Stage 5 - the finished painting

Stage 1 (*page 47*)

Draw the outline of the lower edge of the sky where it meets the details of the landscape. Wet the sky area and lay in washes mixed from hooker's green, ultramarine and crimson red. Keep these extremely pale without hard edges.

Stage 2

When the sky is dry begin work on the bridge and houses on either side with a mixture of raw umber and sepia with Prussian blue. Leave patches of white on the roof-tops and along the top of the bridge for a layer of snow. Use a mixture of sepia and Prussian blue for the darker shadowy areas on the buildings and under the bridge, and for the shadow of the bridge in the water.

The features in this stage are all hard shapes, so the drawing and perspective must be correct. Nearly all the other features of the landscape allow a certain amount of artistic licence, but the man-made structures must look realistic.

Stage 3

Indicate the distant trees beyond the bridge, using dry-brush to paint delicate shades of hooker's green, ultramarine and crimson red, raw umber and sepia. Leave the uppermost parts of the trees white for snow. When the foliage is dry, put in shadowy trunks and branches with diluted sepia.

Make a very pale wash from ultramarine and crimson red and lay a shadow across the roof of the house on the right.

Stage 4

Draw in the edge of the river bank in the foreground. Put in a dark area of shadow for the overhung area with a mixture of raw umber, sepia and Prussian blue. Keep the edges of this hard to give a jagged effect. The river reflects the colours of the sky and the trees and foliage on its banks. Use a wash mixed from ultramarine and crimson red for the river surface in the distance. Paint in the mass of undergrowth on the left bank with burnt sienna, ultramarine and raw umber to

48

give the effect of a tangled mass. Blend the sepia wash into the river with water to create the correct reflection. Complete the water surface by using a very pale wash of hooker's green and ultramarine. Use sap green, sepia and Prussian blue to paint the conifers on the right. Study the brushwork for these trees: the angle of the brushstroke as much as the colour makes the trees look like conifers.

Stage 5

Add fine details to the buildings and their stonework to give them character. Give shape and form to the snow-covered foreground with washes of hooker's green and ultramarine and include a few dashes of sepia wash around the edge of the river bank.

Finally, paint in the bare saplings in the lower left- and right-hand corners of the painting with the same colours as for the foliage on the left-hand side of the bridge on the opposite bank. Do not make these lines of paint too dark or the effect will be too heavy against the snow.

Hooker's green and ultramarine, although originating in the sky, are reflected in all the light areas throughout the painting. This gives an overall unity to the work.

Rocky ravine

Commentary and paintings by Jan Burridge

Size: 265 × 265 mm/10½ × 10½ in.
Brushes: 0, 1, 2, 6 sable. Paper: Bockingford 285 gsm/ 140 lb.

Rocky headlands, steep cliffs, highland outcrops and rough boulders are good subjects. Angular outlines and sharp shadows, together with a wide range of colours and textures, give opportunity for experimentation and a combination of different techniques.

Practise these techniques on a spare sheet of paper before attempting a finished picture. Apply pigment very loosely with a large brush and lots of water. Let the paint produce its own shapes and patterns as it dries. Create interesting textural effects and highlights by gently lifting out the colour from certain areas with a clean sponge, rag or paper tissue while the paint is still wet. Wash colour from dry areas by first applying water to loosen the pigment. Use stippling techniques to create rough textures. Apply colour with minimal water and use a large brush. Colour applied in this way can always be manipulated afterwards if you use more water to blend and soften tones. Notice the contrasts between areas where two or more colours have been applied separately using this technique, and areas treated with the same colours mixed previously on the palette and applied together as one wash.

Demonstration

Stage 1 (*page 50*)

Establish the outline of the glimpse of sky at the top of the picture by drawing the silhouette of the stone footbridge above the waterfall and the rough wall leading away from it to the right. Wet the sky area and lay in a wash of very pale yellow ochre, thus emphasizing the darker areas of colour at the edge of the sky. Put a slight amount of ultramarine in the centre of the sky to give an impression of pale blue among the light clouds. For the shadow under the bridge use a mixture of sepia and Prussian blue and add the shape of the distant forest with the same colours. Let the paint dry.

Rocky ravine demonstration

Stage 1

Stage 2

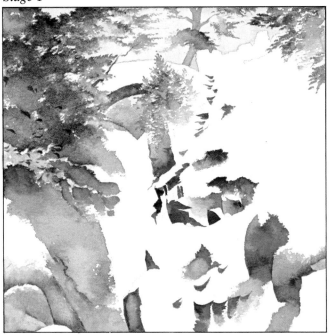

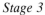

Stage 3

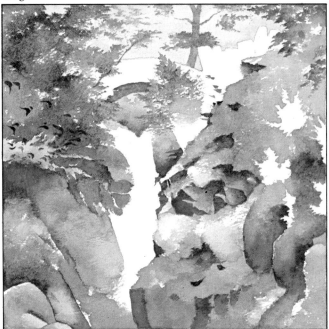

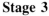

Stage 4

Stage 2

Isolate the outcrops of rock and establish the outline of the waterfall and ravine. This is the most important stage of the whole painting as these stony features provide the backbone for a wide range of colour and textural effects. Lay in these areas with varying proportions of sepia and Prussian blue. Keep some edges hard and blend others off with water where the undergrowth overhangs them. Lift out areas of colour to give some tonal variation. Do not apply the paint too thickly: it is better to make a wash too thin than too heavy. Let all these areas of paint dry thoroughly.

Stage 3

Now begin work on the trees and foliage at the top of the ravine. Use sap green, sepia and burnt sienna. Wet small patches of the paper and softly paint in these colours. Let the paper dry and then use drybrush for a leafy effect and encourage the development of a speckled light from behind the foliage. I have used different brushstrokes for different types of foliage. Practise short dabbing brushstrokes with a no. 1 sable for the effect of the coniferous tree directly in front of the footbridge.

Rocky ravine demonstration

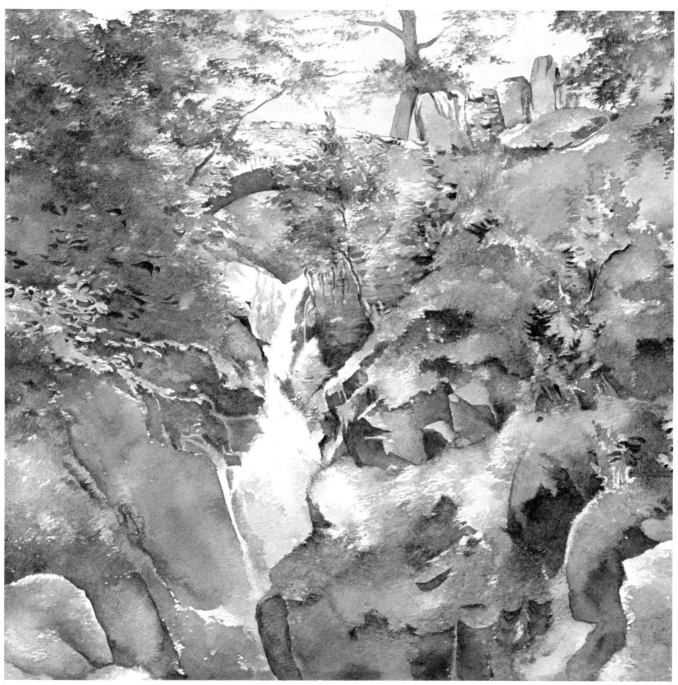

Stage 5 - the finished painting

Stage 4

For wet grass and moss on either side of the waterfall, use sap green, hooker's green, yellow ochre and raw umber in varying wash proportions above the rocks. Wet patches of the paper to allow these colours to merge into one another and let them flow over the tops of some parts of rock to give a realistic overgrown look. Small speckled patches of white paper show through these washes and are important to the overall effect of the painting.

Stage 5

Complete the painting with very thin washes of ultramarine and sepia to produce the waterfall, the stonework on the bridge and the rocks leading away to the right. Put in some ferns on the right-hand bank with drybrush and sap green, burnt sienna and Prussian blue.

The pleasing effect of this painting is mainly due to the strong feeling of light emerging from behind the bridge and passing through the trees but not quite penetrating into the moist, dark depths of the ravine.

Seascape
by Leslie Worth

Introduction

Painting the sea presents certain problems. It reflects moods of light and weather and is affected by changes in the seasons. It also has its own moods and behaviour patterns and calls for a responsive temperament, together with keen observation and preferably sound technique, to overcome these challenges. The following examples avoid the more complex tempestuous situations, and will illustrate basic principles on which you can build your own particular approach to the subject.

You cannot learn to paint simply by reading books. Treat a book rather like a map for a journey: it is helpful and is based on sound observation (which is very important) and offers fairly simple technical advice. Compare this with your own experience.

Painting by the sea is full of problems and vexation, as you may have already discovered when your paper falls into the water and the wind blows sand into your paint-box; so you will have to use your ingenuity and common sense to avoid these pitfalls when you work out of doors. If you work indoors from drawings and notes, then you will need to note the overall mood and lighting conditions and to make a key of comparison to measure the relevant colour values and tones. The information you collect while out of doors gives authenticity and freshness to the painting carried out in the studio.

You can learn a great deal from studying the work of painters who have successfully dealt with this subject – not just to copy them but to discover what basic principles they embody in their painting. Above all, nothing of value can be achieved without hard work. Carry out lots of studies, concentrating on one problem at a time, and do not be discouraged if you fail to achieve what you set out to do. Persevere and try to examine critically your efforts.

Sea and sky

Because of the obvious interdependence of these two elements, they have been combined in one demonstration.

The Sky

The sky, being the source of all light, is the dominant feature and exercises a governing role in the painting. By its nature it establishes the mood of the painting, be it peaceful, tempestuous, buoyant or oppressive.

It can be complicated, so it is essential that you should look at it carefully to discover the basic organization. You will find yourself in appalling difficulties if you sit down and try to copy what you see without analyzing the subject and interpreting it in terms of what the medium can cope with.

Obviously, basic technical considerations will determine how you work. For example, you can only work: 1. from light to dark; 2. from top to bottom of the paper (because watercolour washes run downwards); 3. from relatively large and simple masses to the more complicated.

Examine the sky and note the position of the sun, the direction of the wind, movement of cloud masses, flow of colour, and so on. Be selective and simplify.

The Sea

The same basic principles should be followed in painting the sea. From a physical point of view, the sea will start where the sky finishes on the paper; this invariably gives a less hard line than one imagines. The horizon may be five miles distant or more, depending on visibility and the position of the observer.

The sea is basically a reflecting surface and depending on its own activity, rough or calm, will incorporate colours found in the sky. The changes in its surface, shadows of waves and so on, should not be overstressed. Light areas, such as breaking waves, may be left as virgin paper, or, if they are small and isolated, picked out with a sharp knife.

The water surface is not uniformly translucent. Near the beach where the depth is shallow, the underlying colour of the shore will influence it, and it will often be a rich green. Farther out the colour is heavier and will change, sometimes subtly, from left to right.

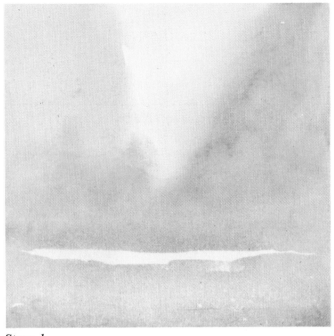

Stage 1

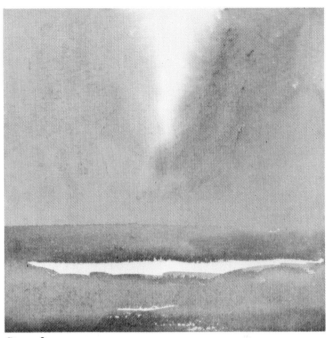

Stage 2

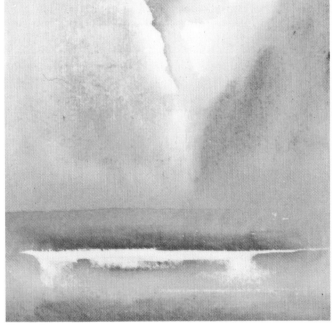

Stage 3

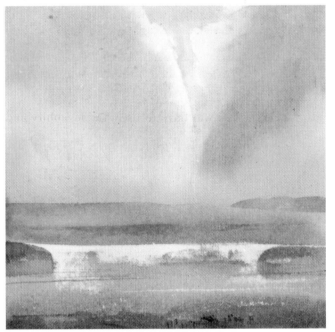

Stage 4

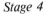

Demonstration

Size: 180 × 180 mm/7 × 7 in. Paper: TH Saunders NOT 135 gsm/90 lb. Brushes: 7, 10 sable. Time taken: about 2 hours.

Stage 1

Establish the key or mood of the painting at this stage. The sky is the most important factor as it is the source of light. Lay on a soft wash, keeping the colours light and airy and aiming for simple spaciousness. The col-

ours used here are: raw sienna, indigo, Prussian blue and sepia.

Stage 2

Colour in the sea and foreground beach to establish them more firmly. Strengthen the sky by adding colour, but do this carefully or the sky may become too heavy. Dampen the horizon on the right to allow the stronger tone on the left to bleed out.

Stage 3

To complete the sky, damp the surface of the paper

53

Sea and sky demonstration

Stage 5 — the finished painting

with a soft sponge and paint in the clear blue area, diminishing it in strength downwards.

Give shape to the top of the breaking wave by using a sharp blade to lift out the painted area. Do this very carefully or you may damage the surface of the paper.

Stage 4

Put in further details of the headland on the right, and the dark line of the wave in the middle distance. Put in the darker areas inside the breaking wave and darker accents in the beach foreground. Take great care to

avoid overstating the tonal values of these details when you add them in.

Stage 5

The final painting. Little is added to the previous stage, except details. Put in the figures and the gull at this stage, and not before. Consider their scale and tonality and put them in on dry paper to give them sharp edges. Add a few details on the beach and lift out some light streaks in the foreground with a sharp knife.

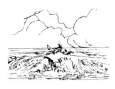

Dinghy off the coast

This wash demonstrates what may be achieved very simply. The painting is almost 'premier coup': very little has been added to the work after stage 1.

It encompasses a simple colour structure of blue and orange opposites, with 'buffer zones' in between of sienna, umber, violet and blue/grey. There is a balance between soft focus areas and sharply defined forms. These enable you to explore the possibilities of painting into damp and dry areas, and at a later stage to paint directly with the brush without preliminary drawing.

Damp the paper in advance, with the exception of the light area of cloud to the right, where a crisp edge is required. Progress from the broad washes to more detailed work. Devote the final stage to giving more definition to some of the forms where necessary.

The painting was completed in one session although a certain amount of revision of the near foreground took place about a week later.

Demonstration

Paper: Arches mould-made paper, 'NOT' surface 180 gsm/90 lb. Colours: raw sienna, light red, madder brown, sepia, Prussian blue and indigo. Brushes: sable 10, 9 and 6. Time taken: 2½ hours.

(I do not think there is any great significance in the brush sizes. Basically a larger brush is advisable for large areas, sky for instance, and a smaller one for the more detailed passages.)

Stage 1

As in most paintings, the object at this stage is to establish the 'mood' of the subject and to ensure that the colour range reflects this mood. A fresh breeze is blowing from the sea, piling up the clouds over the land and tilting the dinghy as it turns. Dampen the paper in advance and allow cloud areas to drift into one another. The only two hard edges are on the top right of the big cloud and on the bottom edge of the lower cloud.

Stage 1

Stage 2

55

Dinghy off the coast demonstration

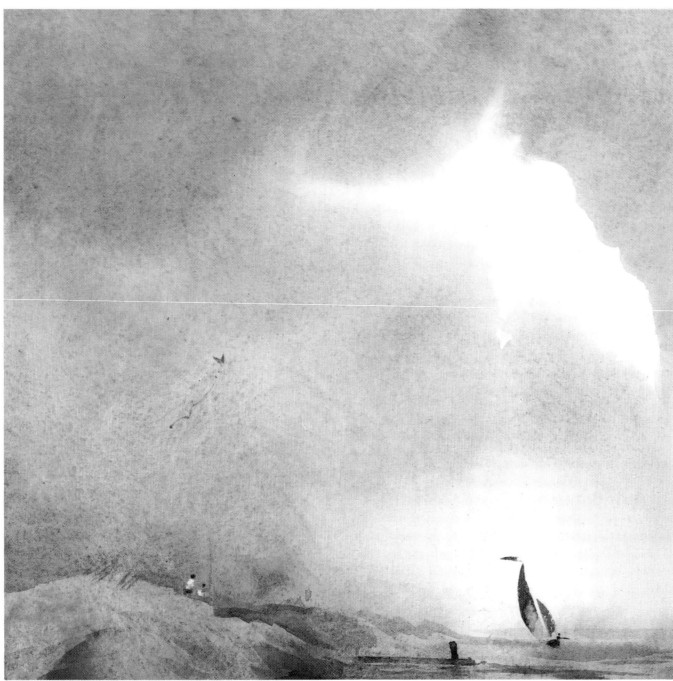

Stage 3 – Dinghy off the coast

Stage 2

It is advisable to allow each separate stage to dry before proceeding, even if it is necessary to dampen some of the areas again. Strengthen the greys in the cloud but do not let any hard edges appear here. Bring out the sand dunes in the foreground by darkening the areas immediately above, and creating an effect of distance.

Stage 3

The sky area is complete now. The final stage consists of adding the figures flying the kite, dashes of dark water, heavier colour to the distant coast and finally the dinghy. It is important to pull together any disruptive or too strong passages in the sky by dampening the paper and lifting out some of the sky above the land.

Grey day at Westward Ho!

This scene is a grey, rather cool afternoon in late August, with a stiff wind blowing in from the sea and the sun concealed by cloud directly ahead. A dark, threatening raincloud is moving in from the far right; the sea is a little choppy, and the breakers just strong enough to offer some encouragement to the surfers in the foreground. (Pages 58–9.)

The subject is rather difficult to paint. Although the grey overcast conditions give a certain cold unity to the subject, the fast-moving clouds are constantly changing the tonal relationships. Sometimes the distant headland appears as a dark band and then, suddenly, it almost disappears from view as a rain shower moves in from the sea.

The moderately rough sea also presents an ever-changing surface, not only through the activity of the waves, but because its reflective character counterchanges in unison with the sky. In these circumstances, the only solution is to observe the conditions very carefully, and decide on one aspect which is quite constant. I have painted a view which, while retaining the essentials, preserves a hint of impending change.

I enjoy painting the sea, for the ever-changing conditions pose enormous challenges and at the same time offer beautiful tones and colours to exploit in a painting.

Be careful not to make the mistake of thinking that the activity in the sea must be matched by a comparable activity on the paper. If you try to match wetness for wetness, you will achieve the disappointing, inevitable result of simply creating chaos. Keep a broad view over the entire subject, and observe the characteristic rhythms of the sea. Make your selection of subject within your painting ability and then stick to your plan of working.

Demonstration

Paper: Arches NOT 180 gsm/90 lb. Brushes: sable 10, 9 and 6. Colours: yellow ochre, sepia, monestial blue and Chinese white to give a hint of opacity to the greys. Time taken: 3 hours.

Stage 1 *(page 58)*

Draw lightly in pencil the main outlines of the subject; the placing of the horizon is most important. Do not make the lines too heavy. Now apply soft washes, wet-into-wet, and aim for an overall atmospheric effect in the sky. Allow this stage to dry completely *before* embarking on the next.

Use very few colours, varying the proportion of ochre, sepia and blue to one another, and also the degree of water content. This will produce a wide, though subtle, range of warm and cool greys. Experiment with these mixtures on a spare piece of paper, before embarking on the painting.

You will find it a great help to make some drawing studies prior to painting, to plot the main areas of design and the range of colour values and tones.

Stage 2

Now try to establish the general colour values of the sea and beach. It is necessary to dampen the paper surface before applying colour, in order to avoid hard edges forming. Leave the light area of the breaking wave as virgin paper, and in later stages use a sharp knife to 'feather off' the tapering crest of the wave.

Apply modifying washes of colour to the sky at this stage. I usually paint the sky 'premier coup' (at one go) and then blend it in with the sea, but for clarity in this demonstration I have divided the process between the four stages of the painting. Notice how the far right horizon of the sea has a soft grey-blue tone and a soft edge. This suggests distance, without overstating colour.

Stage 3

Paint in the distant headland as a cool blue-grey band at this stage. Dampen the paper slightly at the left-

Stage 1

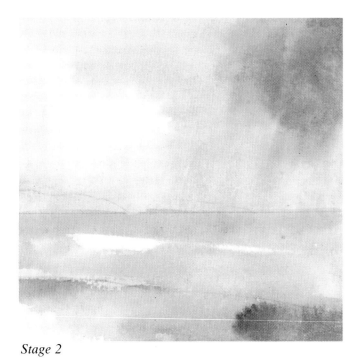

Stage 2

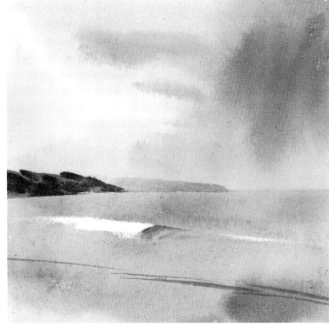

Stage 3

Stage 4

hand edge to suggest a misty contour, and add the nearer, darker headland as a key to the middle grey values. The headland consists of basically two tones: a cool, dark value (blue-sepia) on top of a warm colour (ochre-sepia). Watch the relationship between these two values and keep them close.

Stage 4

In practice there is no break between this stage and the former, and little specific development. The main objective is to complete the sea and at the same time to pull together any tonal area values which appear too isolated. Do not let the darker headland appear too dark in comparison to the adjacent sea passage or it will appear to 'float'.

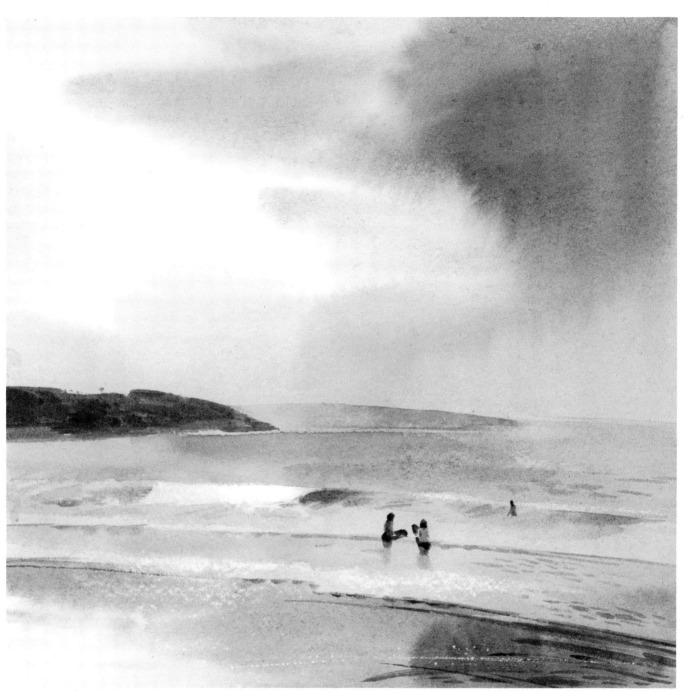

Stage 5 — the finished painting

Stage 5

The final painting. I hope this stage is self-explanatory. The basic work has already been done and you can now indulge in the finer points. Put in the figures to help give scale to the painting. The scale or size of the figures is crucial; if they are too large or small, they destroy the effect of the painting. Dampen the paper lightly at the base of the figures to integrate them into the water.

Add the final details of the sea and foreground, and pick out light areas with a sharp knife.

59

Sunset at Sennen Cove

This painting was made from notes drawn on the spot at Sennen Cove, at sunset in August.

I chose to paint this sunset because its rich colours and rarefied beauty presented a challenge. Painting a sunset can easily decline into a mess of colour and many painters are lured into a quagmire of difficulties by an impulsive response to the beauty of the subject. Of course it is precisely the vibrant colours which are the attraction of a sunset and the most difficult aspect to deal with. Do not make the mistake of using too much colour, for economical use of paint is likely to be much more successful.

Remember that you are dealing with the behaviour of light that is given some body by the presence of cloud, vapour, mist and other translucent vehicles of colour, which enjoy a brief, but brilliant existence before declining into cold obscurity. Do not make the handling too heavy. To begin with it is better to desist from painting at the time, in favour of making some clear, analytical notes as a guide for future work. In this way you will learn to make useful notes of your observations.

This scene is a quiet evening following a hot day. The sea is as placid as a mill pond with no visible division between sea and sky. The warm air meeting the cooler air above the sea produces a violet mist lying along the horizon. The slightly watery, setting sun is directly ahead at top dead centre.

A setting sun always presents a problem. It appears as a red disc – but as pigment is *corporeal*, it cannot be used to represent the source of light which is *ethereal* being both *light* and *coloured*! It is impossible to add colour to white paper and make it lighter, so leave the sun as white paper. It is interesting to note that Turner recognized this dilemma and adopted this and other solutions to overcome the problem.

Demonstration

Paper: RWS hot-pressed, 150 gsm/72 lb. Colours: whole pan artists' watercolour: cadmium yellow, chrome orange, alizarin crimson, violet, Prussian blue. Chinese white was added to the violet to give just a little opacity to the distance. Brushes: sable 10, 9, 6. Time taken: 3 hours.

Unlike most examples in this book, because of the simple purity of the subject, it is necessary to move towards the finished painting as directly as possible without the build-up of several preliminary stages. So examples 1, 2 and 3 are simple preparatory notes and only stage 1 is the basis for the finished painting.

The painting was made later in the studio from notes made on the spot, with such support as my memory would allow.

Example 1

This is the original working drawing, which contains colour notes chiefly, with two evening anglers providing a useful note of scale for the painting. Sunsets happen very quickly – this one was all over in about fifteen minutes – which is one good reason for relying on drawings and notes. Range of colour, focus of accents and scale are the main considerations.

Example 2

This is a colour index, designed to describe the range and progression of colours. The range spans the spectrum from yellow to violet. The yellow/orange range is dominant, and the other colours support and complement it in varying proportions.

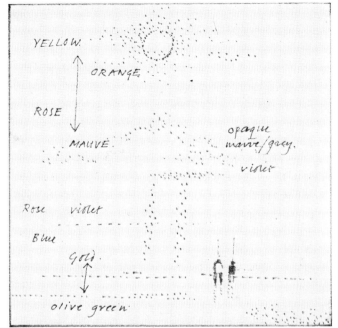

Example 1

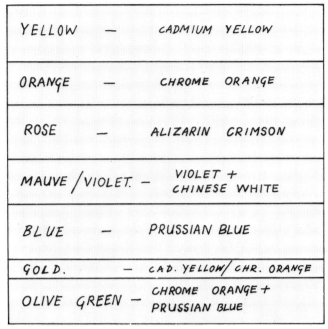

YELLOW	—	CADMIUM YELLOW
ORANGE	—	CHROME ORANGE
ROSE	—	ALIZARIN CRIMSON
MAUVE / VIOLET	—	VIOLET + CHINESE WHITE
BLUE	—	PRUSSIAN BLUE
GOLD	—	CAD. YELLOW / CHR. ORANGE
OLIVE GREEN	—	CHROME ORANGE + PRUSSIAN BLUE

Example 2

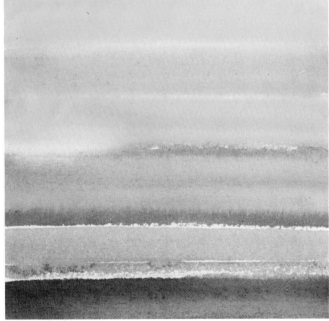

Example 3

Stage 1

Example 3

This is simply a colour chart showing the colours as they come from the box, from yellow to green, light to dark, from top to bottom. In practice, as you can see in stage 1, the colours used are paler: if they are too strong, the sense of space and luminosity is lost.

Stage 1

This is the basis for the finished painting. Dampen the paper overall in advance, and lay in the colours lightly from top to bottom. Leave the centre of the sun as white paper.

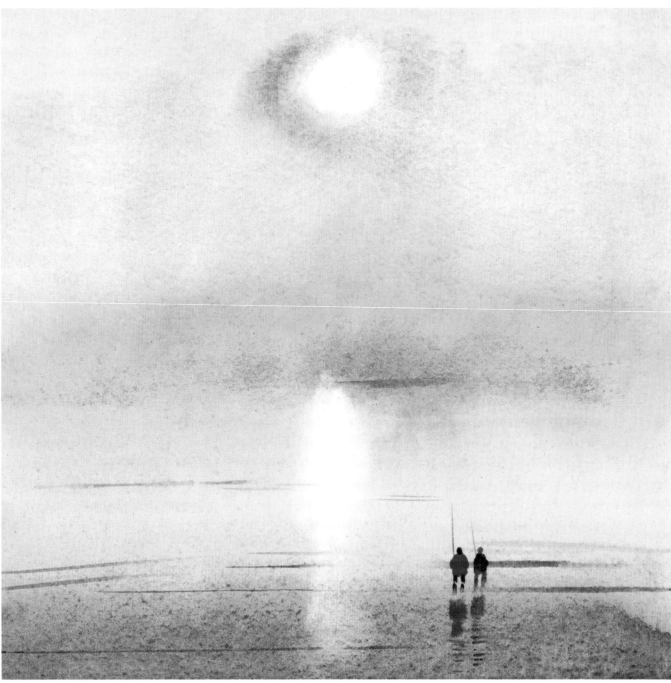

Stage 2 – the finished painting

Stage 2

The finished painting. There is little to be done at this stage, which is why the previous stage is crucial. If the colour is already too strong, lift out some of it with clean blotting paper or rag.

Add the accents of figures and ripples of waves. This paper is hot-pressed and as the surface is very smooth, wet-into-dry accents may appear too hard. To avoid this, dampen the paper slightly before painting in the fine details.

Lift out the light track in the water with a fine sponge and rag. Be careful – the surface is easily rubbed up!

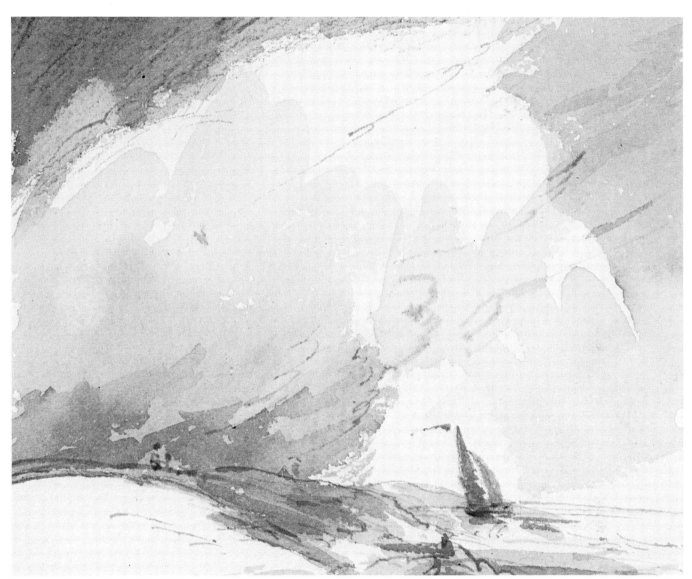

Fishing boat on the beach

This is a quick sketch to crystallize the idea and establish the mood, using a pen and pencil and a sepia wash.

If you are interested in painting the sea, you will be attracted to boats, which are almost part of it. The beauty of their shape and strong colour make an absorbing study, so it is appropriate to include one quite detailed study. (Pages 64–5.)

The example is based upon studies of Yorkshire cobles, which are off shore fishing boats. The scene is of a broad beach with cliffs in the distance. A warm, late afternoon light illuminates the beach and thunder clouds are gathering against the cliffs. The boat is a sturdy broad-beamed craft with a shallow draught, designed for negotiating hazardous shallow approaches to certain harbours where rocks lurk just below the surface.

However, although the boat provides the subject matter, the painting is not just a portrait and the boat is chiefly a focal point within a view of the sea and shore.

The warm tones of sienna, russet and madder foil the sharp turquoise blue of the boat, and much of the intricate detail of the shore line and cliffs is repressed in order not to distract attention from the boat. The anchor and corner of dark rock in the foreground are a useful foil to the boat, and by their presence help to project the boat back into the middle distance of the picture.

The boat presents particular drawing problems (not all of which have been successfully solved – I fear), so apart from allowing a little of the neighbouring colour to break into the silhouette, wait until the final stage before concentrating on painting the boat. Do not make the boat too detailed or it will appear out of context.

Stage 1

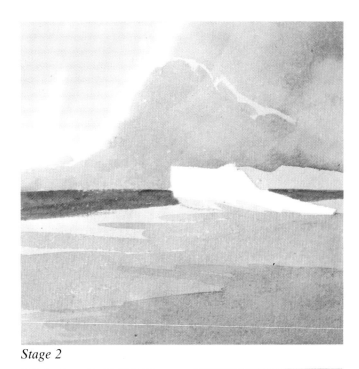

Stage 2

Stage 3

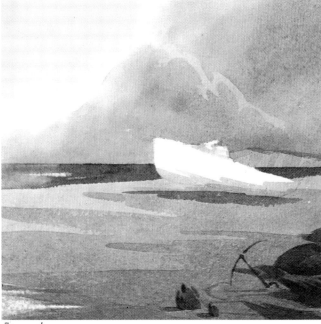

Stage 4

Demonstration

Paper: Arches NOT 180 gsm/90 lb. Colours: raw sienna, brown madder, sepia, Prussian blue and indigo. Brushes: sable 9 and 4. Time taken: 2¾ hours.

Stage 1

First make a very fine pencil drawing to locate the boat. Then add a light wash indicating the sky and surrounding warm colour of cloud and beach, working on a damp ground. It is important to establish the overall 'key' of the work with raw sienna, brown madder and Prussian blue, as it cannot be introduced later.

Stage 2

Paint successive washes of madder plus a little Prussian blue in the sky, so that it is almost complete at the end of this stage. Then build up washes of colour in the beach and introduce the deep indigo of the sea.

Stage 3

Indicate the cliffs in the distance and paint in the dark silhouette forms of the foreground rock and anchor.

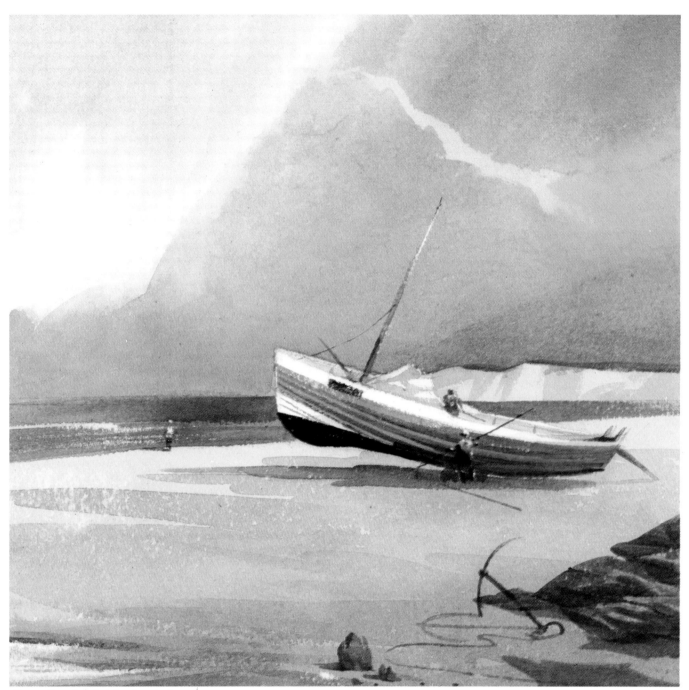

Stage 5 – the finished painting

Lay in cool shadow under the boat with Prussian blue over madder. The painting should have a sense of depth at this stage, if the values are in the right relationship to one another and also in an overall context.

Stage 4

With the exception of the boat, the work is almost complete now. Lift out with a sharp knife the line of a breaking wave on the sea and the small area of water in the left foreground. Build up the details of rock and anchor with successive washes.

Stage 5

If you have carefully built up the previous stages, the final stage almost paints itself. Give the sky a little more depth by brushing indigo into a damp surface in the top righthand corner and beyond the cliffs. Give detail to the rock in the foreground and strengthen the anchor. Finally turn to the boat and lay washes of pale grey to create the shadow areas under the belly of the boat. Then lay in the blue bands on the side when the rest is dry, and pick out fine detail with a small brush. Paint the details of the boat on to dry paper, to give sharp definition. Add the figures last to indicate scale.

A quick rehearsal done in pen and wash to get the 'feel' of the subject.

Breaking wave

Like me, I am sure you have stood on the seashore watching the waves break and marvelled at the pattern of falling water and tried hard to understand the order of this particular pattern. Once you can understand just how a wave breaks, you can begin to paint it; conversely, no amount of technical painting expertise will help if you do not know in which way to direct it.

As an analogy, place your hands, palms downwards, on a table cloth and push in one direction, so that the cloth buckles in long lines. Continue until the ridges of cloth pile up and collapse; this is not unlike the behaviour of the sea on the beach. The momentum of the tide piles up the water, where its weight meets the resistance of the shore. The water, pushed from behind, builds up to a point where its weight cannot be sustained. Then it forms a hollow curve, the crest at the top overspills the centre of gravity, and water crashes down in a curving arc of white foam. At the same time, patterns of foam slide down the hollow inside the wave to mingle with the foot, where the backwash of expended wave retreats back down the shore.

On the ridge and crest, the activity of water builds up the familiar white foam, which is opaque. The hollow ridge of the wave is semi-translucent, particularly just before the arching crest, where the collapsing ridge is at its most narrow and the colour fractionally lighter and luminescent. The larger the wave (and therefore the more rapid the rate of its fall), the more regular is the curve of descent which, by its momentum, overshoots the forward edge of the ridge, throwing the characteristic pool of shadow on its concave surface. At the base, where the volume of water hits the shore, is confusion; the water rebounds on impact in leaping and dancing spouts of white foam. These give way to the shallow ripples advancing and retreating with the backwash. The colour here is at its most vibrant because the shallow shelves of water throw up the underlying colour of the beach and the light reflection of the sky.

Demonstration

Paper: Arches NOT 180 gsm/90 lb. Colours: raw sienna, light red, Prussian blue, indigo, sepia. Brushes: sable 9 and 6. Time taken: 3 hours.

Stage 1

This diagram shows the directional movement of the breaking wave. The arrows indicate the thrust of the water; the main movements are at the top of the ridge and over the crest. The secondary movements are on the concave sides of the ridge. Make a drawing like this to isolate movements, whenever you paint a moving subject.

66

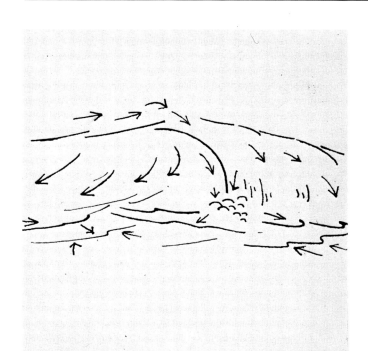

Stage 1

Stage 2

Stage 3

Stage 2

In practice, paint the study almost in one go, but for the sake of clarity here, I have broken it down into successive stages. Paint the area of heavy, stormy sky in thin washes into a wet ground, using downward brushstrokes to give weight to the atmosphere. Leave the wave and paint the sky down to the top of it.

Stage 3

Use a light, yellow-grey wash to indicate the hollow side of the wave and a darker wash to suggest the shadow of the crest.

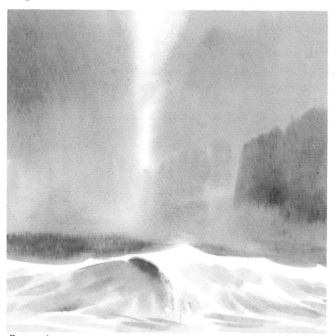

Stage 4

Stage 4

Lay in the horizon and the distant sea beyond the ridge on a damp surface, to avoid hard edges. Strengthen parts of the sky. Make more description in the wave with brushmarks that follow the movement of the water, as shown by the arrows in stage 1.

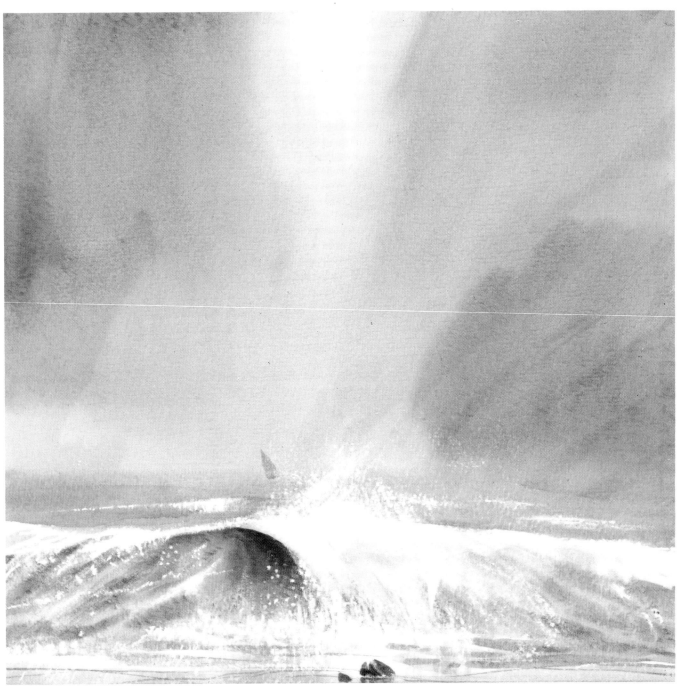

Stage 5 – the finished painting

Stage 5

Build up additional washes lightly to reinforce the colour in the wave and foreground beach. Use a sharp blade to lift out the areas where spray is thrown up, and for the lighter tracks of foam. It is too difficult to laboriously paint around the small white areas. Do not use body colour as it can look heavy and freeze the motion of the painting. Lastly, put in the yacht and the rocks on the beach to give scale.

Lyme - 8-7-79

A sketch of surfing yachts made on the spot. It is an invaluable memory aid for a later painting.

Surf-sailing

After the turbulence of the previous study and its difficulties, here is a quiet, peaceful seascape. I was intrigued by the sight of surfing yachts which are not easily handled, as I had ample opportunity to observe. It was in one of those rare moments when the hapless surfer was vertical that I made some studies. The subsequent painting, on the next pages, is painted from memory with the aid of drawings and photographs.

Much depends on the accuracy and delicacy of the drawing of the yacht, and there is no easy way to do this. As I have shown in other examples, there is no substitute for acute observation, and the relationship of the scale of the subject in the surrounding area of water is a matter of careful observation as well as artistic sensibility.

The sea presents particular difficulties because it is so undisturbed. Its surface colour is almost unrelieved. A deep indigo extends to the horizon and appears as a hard line. I have tried to avoid the tendency to make it look flat and vertical by subtly modulating the colour, deepening it in the foreground, and as shown in the first stage, allowing the initial washes of blue and pink to lie under the subsequent colour of the sea.

Try to make the plane of the beach and sea consistent, although in this instance there is a slight decline of the beach up to the edge of the water. Dampen the paper gently at the horizon before painting to soften the edge of colour at this point. Usually the strongest colour value occurs just below the horizon.

Above all, the colour values and their relationship to one another must convey the light of a hot sunny afternoon, with only the gentle progress of the yacht from right to left disturbing the motionless setting.

Demonstration

Paper: Arches NOT 180 gsm/90 lb. Colours: Prussian blue, raw sienna, alizarin crimson, indigo. Brushes: sable 9 and 4. Time taken: 3¼ hours.

Stage 1 *(page 70)*

There is an underlying warmth of colour, so lay in a faint pink wash under the blue sky and make it stronger at the base where the beach is. Both the blue and pink washes are very thin and darken just a little at the top and bottom.

Stage 2

Paint in the narrow band of sky above the horizon on a damp surface. When this is dry, paint the indigo of the sea, leaving hard edges above and below. Leave the triangular area of the yacht sail untouched.

Stage 1

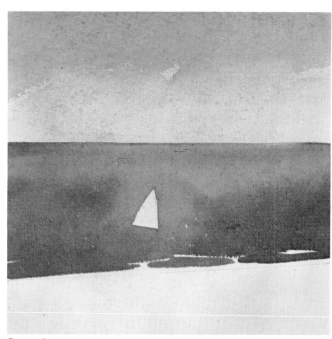

Stage 2

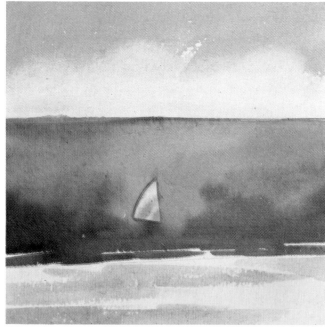

Stage 3

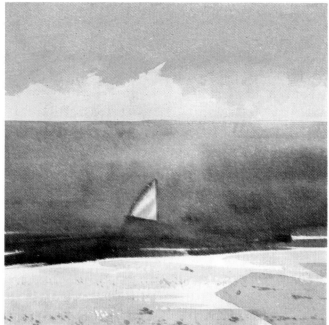

Stage 4

Stage 3

Paint the changes of colour on the beach into wet and dry paper to give hard and soft edges. Modify the colour of the sea by adding further thin washes on the shore edge and on the horizon. The nylon sail of the yacht (apart from the dark stripes) is not entirely flat: brush in bright colour to give shape and indicate the ripples made in the sail by the faint breeze.

Stage 4

This is really an extension of the former stage. Deepen the colours of the sea where necessary, soften the edges of the colours on the beach, and show where the shadows cast by the beach huts are flung across the right foreground.

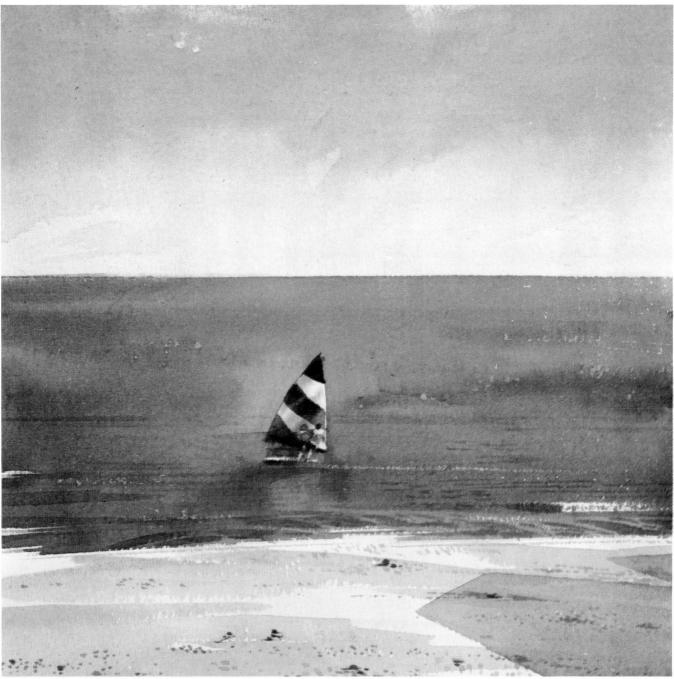

Stage 5 – the finished painting

Stage 5

This final stage hopefully gathers together the work so far. Paint in the detail of the yacht and figure with a fine brush, being careful not to over-emphasize them. The dark stripes of indigo and alizarin crimson on the sail, appear virtually black. A careful scrutiny of the sea reveals subtle ripples of movement in the water. Pick out the base of the yacht, the track in the water and the breaking wavelet with a sharp knife.

Boats at Staithes

Boats are featured in this painting, but they are not the centre of attention. This exercise is chiefly concerned with the problems of painting a large expanse of agitated water. The boats are only necessary as a focal point. (Pages 73–4.)

It is a fresh afternoon with showers of rain, in a fishing village on the coast, popular with artists for many years because of its picturesque jumble of cottages above the harbour. A high tide is running with a swell, waves are breaking over the submerged rocks in the harbour mouth and the sea is spilling over the breakwater that makes a diagonal line to the quayside. Three Yorkshire cobles are moored inside the breakwater and they dip and roll as the sea heaves around them.

As you can judge from the position of the horizon, I am looking down on to the water, and therefore looking through the translucent surface as well as across it. The deepening colour in the foreground gives some indication of increased depth at this point. Because of its greater depth beyond the breakwater, the sea appears a gun-metal blue-grey and is opaque. A freshening wind from the sea is fanning out thin cloud over the horizon.

The main problem lies in describing this heaving mass of water which is not flat, and does not have a uniform activity over its surface. The area beyond the boats where the sea is spilling over the wall is choppy, but nearer to the quay it rises slowly like a wet sheet. Sketches of active water present several problems at the same time; there is the mobility or activity, the translucency, the reflective quality of its surface, its colour or colours and its wetness. Should you try to fuse all these elements into one, or make one of these aspects the main theme? I think it best to concentrate on the behaviour of the light and the manner in which the surface is revealed by the light striking it. This automatically involves colour, and form and textural character are inseparable from this. The demonstration is based on this hypothesis. It was made in the studio from a detailed drawing done by the sea.

Demonstration

Paper: Arches NOT 180 gsm/90 lb. Colours: raw sienna, light red, violet, Prussian blue. Brushes: sable 9 and 4. Time taken: 3 hours.

Stage 1

The first consideration is to fix the prevailing lighting and 'feel' of the time and place, especially the sky character and general colour of the sea. Dampen the paper in the sky area to allow for the soft, wispy clouds over the horizon. Paint the sea wet-into-wet, leaving

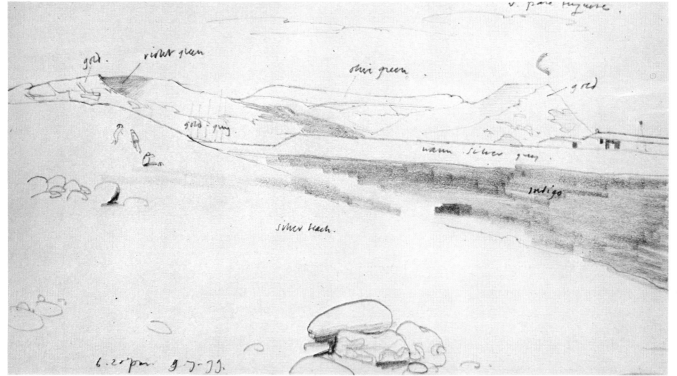

A preliminary working drawing made to establish two parts of the design for a future painting. First, to understand the basic layout of the land and sea, and second, to note the colour values and tones in relation to each other.

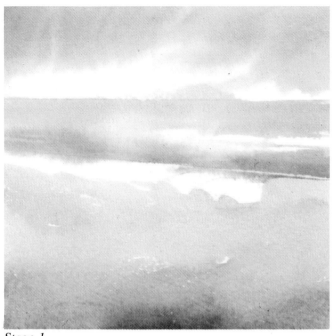
Stage 1

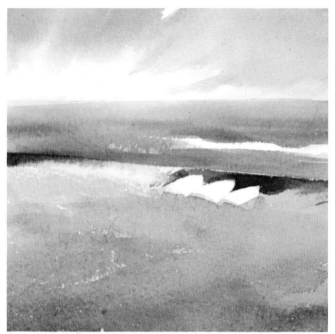
Stage 2

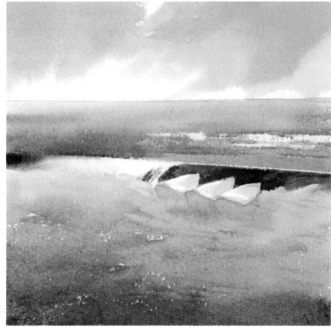
Stage 3

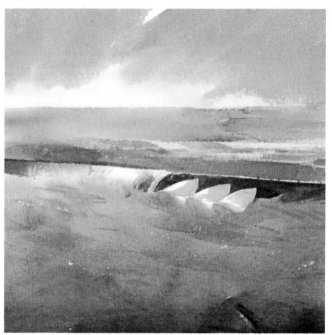
Stage 4

hard edges around the stern of the boats and white paper along the face of the breakwater. Encourage the sea colours inside the breakwater to diffuse widely.

Stage 2

Give the sea within the breakwater and beyond an additional fine wash of raw sienna, to distinguish it from the sky. Paint this on to dry paper to encourage breaking up across the rough paper surface and achieve foam and wave crests. When dry, paint in the break-water leaving a thin white line along the top.

Stage 3

In practice this is inseparable from the previous stage. Notice that the water in the harbour has more form to it made by brushing the soft, darker areas of colour into a damp surface: hard edges on the tones will destroy the limpidity of the water.

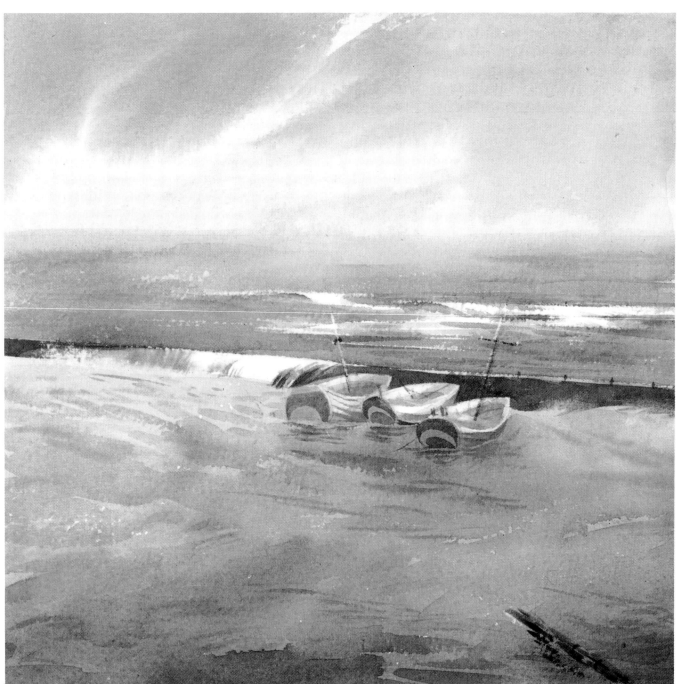

Stage 5 – the finished painting

Stage 4

To suggest that water is spilling over the breakwater from left to right, wet the paper with a brush at this point on the left, and paint the darker colour of the breakwater into it. A dark line above the spilling waves suggests volume and translucency of the sea.

Stage 5

Soften the line of the horizon with a sponge to create a moist atmosphere in the distance. Paint in the boats,

taking care to integrate the colour of the lower sides with the adjacent sea colour. When this is done satisfactorily, add further subtle washes of colour in the foreground to deepen the effect and give the sea a choppy surface. Put in swift strokes of colour on the righthand edge of the water spilling over the breakwater, just above the boat on the left. This gives a dark tunnel underneath the crashing water. A dark, broken line in the lower right corner produces a breakwater disappearing into the high tide. Use a sharp knife to bring out highlights in the large waves beyond the breakwater.

Mastering Detail
by Richard Bolton

Introduction

In this chapter Richard Bolton describes and demonstrates those techniques necessary for working with subjects which need very detailed attention. Previous work on landscape and seascape has concentrated on developing wash control and a sense of large-scale composition, where no single feature of the view dominates.

In the following pages, however, the focus changes to highlighting a special subject, and making it stand out distinctly from the rest of the surroundings. This demands even greater control over your brushwork than you have experienced so far, and, more important, your ability to draw well will be called upon consistently. As explained in the first chapter, drawing is a foundation skill of painting, not only because the preliminary sketch forms the skeleton of the final study, but because good drawing shows that you can concentrate sufficiently to master detail rather than using techniques to blur it.

Although you can create some excellent paintings in watercolour without this mastery of detail and draughtsmanship, in the end you will find that you are limited, and this can be very frustrating. With practice and patience you can strengthen your drawing, and this will give you the necessary confidence to attempt more complex work.

Another new technique is introduced in this chapter – the use of masking fluid. This will make for extra accuracy in delicate outlines, as well as creating interesting texture.

Great Gransden windmill

This deserted old post-windmill is exactly the kind of subject that excites me. It has broken lines and blotchy areas of colour that demand a sharp and contrasting treatment. The scene breaks down into three main parts: the windmill needs drybrush and wet-into-dry to make it stand out as the focal point; the foreground calls for wet-into-wet to give soft edges to the mass of undergrowth; and the trees lack any definite colour but give shape to the painting. I have left out a road that runs to the right as I felt it detracted from the windmill and impaired the overall composition.

A detail of the painting on the following pages

Stage 1

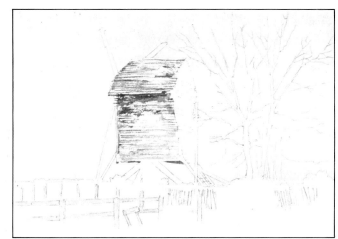

Stage 2

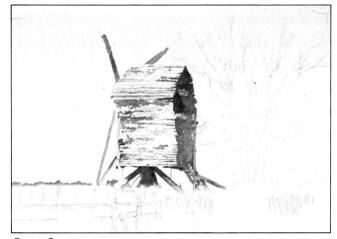

Stage 3

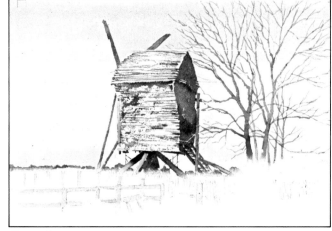

Stage 4

Demonstration

Size 355 × 254 mm/14 × 10 in. Paper: T H Saunders NOT 180gsm/90 lb. Brushes: Chinese bamboo no. 9, 1 sable, flat sable. Colours used: cadmium orange, cadmium red, cadmium yellow, bright red, cobalt blue.

Stage 1

Make a simple drawing of the principal subjects. This is a relatively easy scene to draw as there are no ellipses or complicated details. Do not try to draw each plank of wood of the windmill but create an overall impression with broken lines. Apply masking fluid to the posts in the foreground to produce hard edges and make them stand out sharply against the mass of foliage. I usually begin by painting the background and work forward, and this is what I have done here. Choose a simple sky that does not detract from the subject. Mix plenty of paint and lay in a gentle wash, working from side to side. When you get halfway down the sky, add more water to thin the paint as the paler colour will give distance to the horizon. If you raise the top of the board a little, the wash will bead along the working edge and give an interesting line. Let the sky dry.

Stage 2

The near side of the windmill is made entirely of planks of wood and these provide the greatest challenge in this painting. With watercolour it is possible to create the illusion of planks of wood without actually painting each one. If you try to paint each plank you will lose the freedom which is the hallmark of watercolour painting. Paint the planks by using the side of a moist brush and make quick strokes across the rough paper surface, so that the paint does not reach the hollows of the paper. Practise this technique until you have exactly the right amount of paint on the brush. If you overload the brush, too much paint will be shed on the paper and you will lose the uneven, speckled effect. Give some thought to each brushstroke as remedies are rarely satisfactory and will produce a heavy, muddy texture.

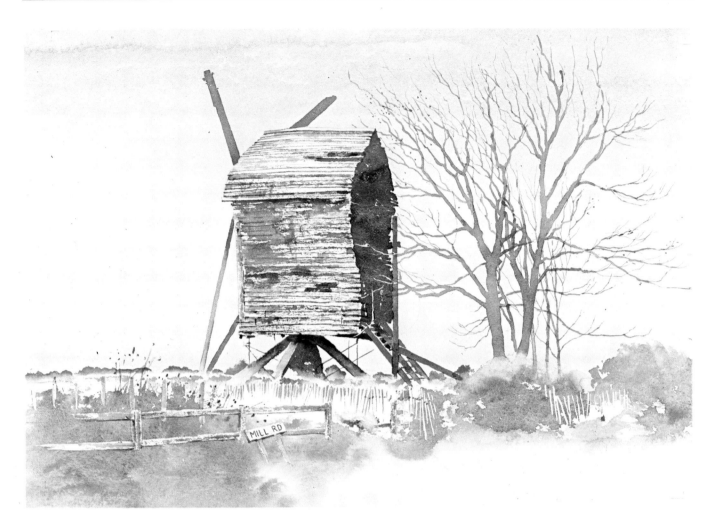

Stage 5 – the finished painting

Stage 3

Complete the windmill by adding heavy shadow on one side and under a few of the planks to give texture. Put in the line of trees to the left of the horizon using pure cobalt blue. Before the paint dries, run a wet brush along the bottom edge of the trees to blend off the colour.

Stage 4

The big problem with the two large trees in the foreground is to avoid hard edges which occur when the paint dries out. Work upwards from the base of the tree. First soften the bottom edge with a damp brush, then work upwards with a well-loaded brush. This prevents the paint from drying out too quickly and enables you to move from one branch to another keeping all the edges wet. Keep the colour subdued so that the trees are not too dominant. Finish off the twigs with a fine no. 1 sable brush.

Stage 5

Complete the foreground with great care. Wet the paper on the left and work in diluted colours, letting them diffuse into one another. Do not push the paint around too much or it will end up looking muddy. Wet some of the area on the right to create patches of white with hard edges. The soft, wet edges of all the undergrowth provide a good contrast to the stark outlines of the windmill. Paint some grasses and posts just below the windmill on to dry paper. Finally rub away the masking fluid on the posts, give them texture with drybrush and highlight them with shadow.

Stage 1

Stage 2

Stage 3

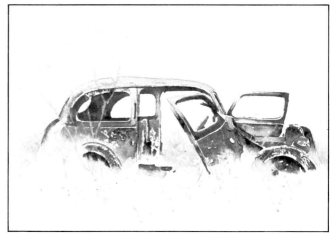

Stage 4

The old Ford

I found this old car rotting away in an abandoned quarry. It particularly appealed to me as I owned one just like it years ago.

The great challenge of this subject was to capture its dilapidated state, the green mould growing over the paintwork and the rust appearing where the paint had come away. Vandals had bent the doors and smashed the glass, providing me with a superb subject to paint.

Demonstration

Size: 370 × 266 mm/14½ × 10½ in. Paper: T H Saunders NOT 180gsm/90 lb. Brushes: Chinese bamboo no. 9, 1 sable. Colours used: cadmium red, cadmium yellow, French ultramarine, yellow ochre, cobalt blue.

Stage 1

After drawing the subject, apply masking fluid to the branches in front of the vehicle and the long grass that reaches up high around the car in the foreground. It is

78

impossible to achieve these thin white lines by trying to paint round the blades of grass, or by painting them in with white paint afterwards. I left the background out altogether as it was a quarry face that did not enhance the subject at all.

Stage 2

Where you start painting the car is not really important. I began in the small corner of the front windscreen (windshield) where there were some harsh lines that allowed me to get the paints wet and to feel my way with the colours. Work towards the back of the car, filling in the darkest areas inside, using a mixture of cadmium red, cobalt blue and yellow ochre.

Stage 3

To paint the doors and body panels, use two brushes, one filled with cadmium yellow and the other charged with a mixture of cadmium red, cobalt blue and French ultramarine. The yellow gives the effect of mould growing round the base of the car. First paint in the yellow

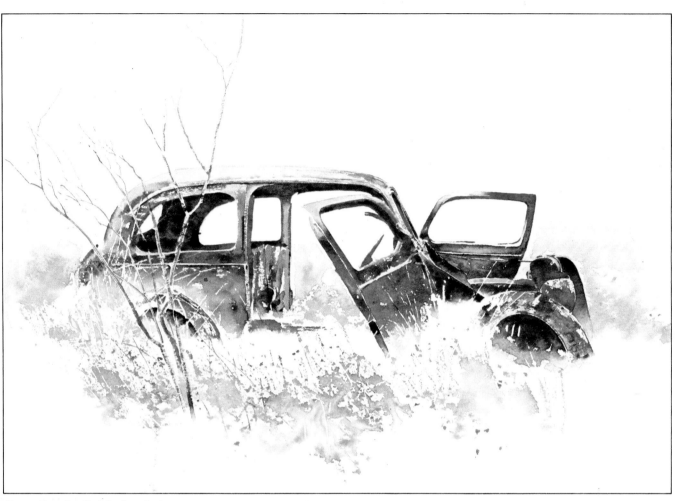

Stage 5 – the finished painting

and, while it is wet, work in the mixture on the other brush. The two colours merge together to create an effect you cannot get in any other way. Try not to overmix colours and do not stir them around on the paper more than you can help, as this only leads to a dulling of colour and a muddy effect.

Stage 4

Mix some cadmium red and yellow ochre and apply it to the interior of the car. Use yellow to suggest mould around the far door. Make up a pale green from cadmium yellow and French ultramarine and place it around the base of the car to suggest undergrowth. Blend this wash at the top with plenty of water so that the hard edges appear only below the car. When painting this car, I found there was too much dark blue around the front mudguard, so I used a little ox gall to disperse the excess colour upwards and create a better tonal balance.

Stage 5

To complete the picture, paint patches of pale green wash into dry paper around the base of the car. Use some drybrush to give broken shapes and when dry remove all the masking fluid from the painting. Paint the tree with a mixture of cadmium red, yellow ochre and dark blue, using drybrush to give texture to the branches. Flick in some dead brown grasses amongst the green undergrowth, and add a few touches of cadmium red below the windscreen (windshield).

Detail of stage 1 on page 81

Tractor and trailer

This ancient tractor and trailer provided an interesting challenge to create textures that show the effect of years of hard use and heavy work. The original colours have faded and are mottled by smears of oil and spreading rust.

Demonstration

Size: 260 × 260 mm/10¼ × 10¼ in. Paper: T H Saunders NOT 180gsm/90 lb. Brushes: Chinese bamboo no. 9, 1 sable, flat sable. Colours used: cadmium orange, cadmium red, cadmium yellow, yellow ochre, burnt sienna, cobalt blue, Prussian blue, cerulean blue.

Stage 1

Drawing the ellipses in the tractor wheels is difficult; take care to draw them correctly. I usually construct an ellipse quite briskly using the natural arc created by my wrist and, if it is wrong, I simply erase it and try again.

The sky is a wash of pure cobalt blue with just a touch of burnt sienna, merging into cadmium orange and yellow ochre. Paint the hills with cobalt blue, and

a mixture of the same colour, burnt sienna and yellow ochre.

Stage 2

Use a mixture of cobalt blue and burnt sienna to brush in the trees and then concentrate on the tractor. Use masking fluid to cover details such as nuts, bolts and various electrical leads around the engine. The wheels are difficult so start with one of these; it is better to ruin the painting now than with the last few brush-strokes. Mix cobalt blue, cadmium red and cadmium yellow for the back wheel of the tractor and work round the tyre, keeping the paint wet and varying the tone. Leave white paper for the highlights on the tyre tread and add a little drybrush for the dirt on the walls of the tyre.

Now begin work on the darkest areas of the tractor. Mix Prussian blue and cadmium red for the hood, parts of the engine and the underside to give the tractor some shape.

Stage 3

The basic colour for the tractor bodywork is cerulean blue with a touch of cadmium yellow. Dab this colour on in thin washes of broken colour to produce the dilapidated effect. Paint in some burnt sienna, using

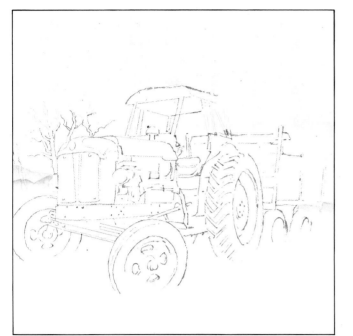

Stage 1

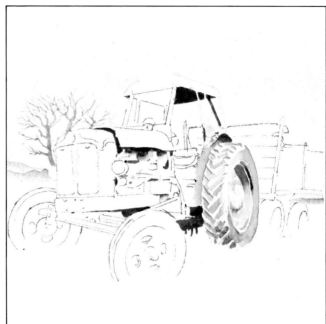

Stage 2

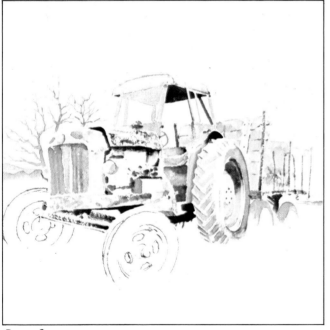

Stage 3

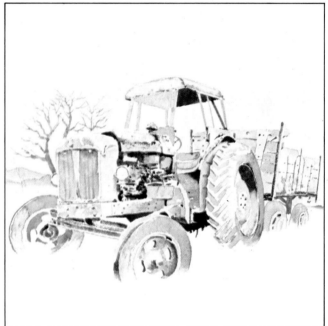

Stage 4

drybrush to create realistic rust. Treat the radiator like a sheet of clear perspex or a similar material by painting some vertical bars of grey and then adding a wash. If you try to paint the grill-mesh wire by wire, it will look overworked.

Use extremely pale washes on the trailer which has lost all sign of its original paint and varnish and has taken on all manner of natural colours. Complete it by adding the rusty frame and some screw heads that hold it together.

Stage 4

Give shape and form to the engine by working in brown made from burnt sienna mixed with cadmium orange, cerulean blue, Prussian blue and a few dots of light green made from cerulean blue and cadmium yellow. Put in some dark nuts and bolts on the vehicle frame, then complete the front wheels with a wash of cadmium red, cadmium yellow and cobalt blue. Do not complete the whole of each tyre, but leave the lower part unpainted.

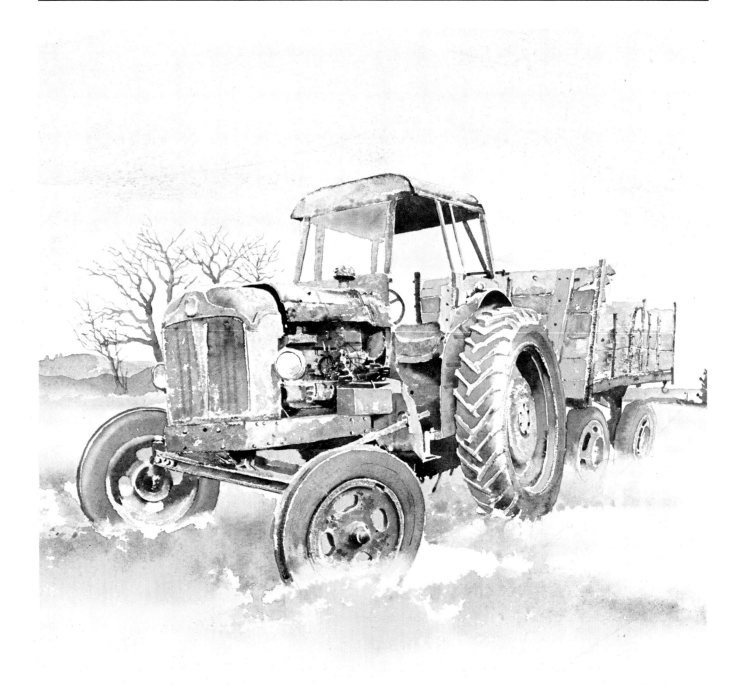

Stage 5

The dead grass around the tractor is a mauve and rust colour. Treat this very loosely, applying lots of clear water and dashing in brushfulls of paint on to dry and wet paper to produce hard and soft edges. There is always some risk when using washes in this manner, though you can soak up the first attempt with tissues and begin again – but remember that the paper will lose its crisp, white surface if you have to resort to doing this.

Finally, remove all masking fluid from nut and bolt heads and the electrical leads on the engine, and put in a *few* fine mechanical details for the sake of realism.

Stage 1

Stage 2

Stage 3

Stage 4

Ancient barges

I could hardly believe my luck when I discovered these three ancient sea-going barges moored at low tide in a river estuary. Their dark low hulls and intricate rigging make them a wonderful subject for watercolour. Before painting them, I took some photographs from different angles as I knew these three vessels would make excellent reference material for many future paintings.

Demonstration

Size: 367 × 264 mm/14½ × 10½ in. Paper: T H Saunders NOT 180gsm/90 lb. Brushes: Chinese bamboo no. 9, 1 sable, flat sable. Colours used: cadmium orange, cadmium red, yellow ochre, burnt sienna, cobalt blue, Prussian blue.

Stage 1

Draw the composition faintly with an HB pencil. Use masking fluid to describe the thin white lines along the sides of the boats, the odd rope dangling over the water

and the anchors on the front of two of the barges. As the sky is quite pale it is possible to over-paint all the rigging details without any fear of the sky disrupting them.

Paint the sky with a wash using two mixtures of paint. First introduce a strip of clear water across the horizon and then blend a mixture of cadmium orange and yellow ochre with a touch of cadmium red into this clear water. Above this apply another mixture of cobalt blue and burnt sienna to merge with the yellows of the first wash. Let this dry before proceeding any further. Put in the strip of dark vegetation on the horizon using Prussian blue with a dash of yellow ochre.

Stage 2

Use a mixture of cadmium red and Prussian blue to paint the dark barge hulls. I never use black as I can get any depth of colour I need by mixing dark colours. When painting the barge hulls, vary the tone so that there are dark shadows and areas of lighter value.

Ancient barges demonstration

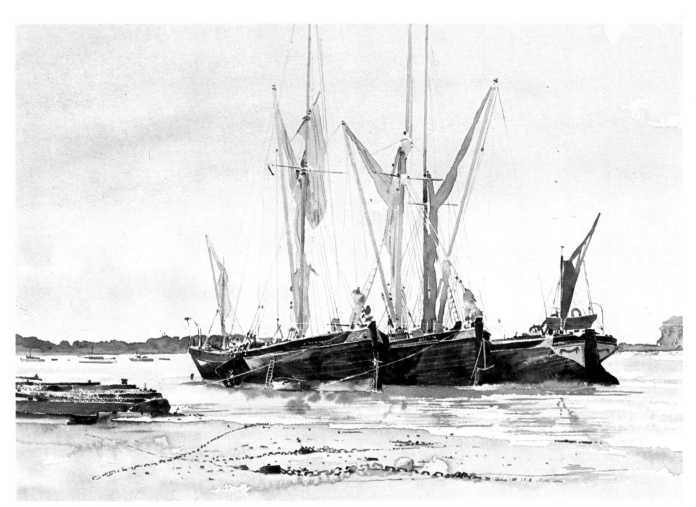

Stage 5 – the finished painting

Stage 3

Work on the masts and sails by using thin washes of cadmium orange and a little yellow ochre for variety of colour. Take great care to keep your brushstrokes absolutely straight when painting the masts. Put in some tiny dots of burnt sienna mixed with cadmium red on the decks of the barges to create detail and interest.

Stage 4

Continue work on the sails and use pure cobalt blue for the ropes that come down from the masts and sails. Put these in with swift sharp strokes using a very fine sable brush. A steady hand is needed to paint the rigging. I find that the easiest way is to swing my arm from the elbow rather like a large compass.

Paint the water surrounding the boats with a wash, tinted with yellow ochre and cadmium orange. Use cadmium red to colour the lower hull of the lefthand barge.

Stage 5

While the wash of the river is still wet, add the blurred reflections of the barges using Prussian blue and cadmium red. When this is dry paint in the ripples on the surface using a no. 1 sable brush. To paint the old jetty timbers on the left, use Prussian blue and cadmium red to describe the dark areas. Use slow brushstrokes for these parts but quick drybrush for the broken effect of timber surfaces. These colours are burnt sienna, cadmium orange and yellow ochre.

Paint the foreground with a wash, introducing colours while still wet. When dry, paint in all the bits of rubbish left by the receding tide. Take considerable care to place the pebbles and give them shape and colour: merely dabbing away with a brush will not give this effect. Run a wet brush underneath each pebble, causing the paint to run slightly and give an impression of wetness to the sand. To finish the foreground add the chains lying in profusion on the beach, using a strong mixture of cadmium orange and cobalt blue. Vary these colours at will.

Finally complete the barges by scratching in some lines on each hull to denote wooden planks.

Section of the finished painting reproduced on page 87

College chapel doorway

Painting architectural detail is not so difficult as it looks. The most important point to remember is that the preliminary drawing must be very accurate indeed. In this particular case, the left and righthand sides of the drawings correspond almost exactly, apart from very minor details of the animals above the doorway.

Demonstration

Size: 254 × 254 mm/10 × 10 in. Paper: T H Saunders NOT 180gsm/90 lb. Brushes: Chinese bamboo no. 9, 1 sable, flat sable. Colours used: cadmium orange, cadmium red, bright red, yellow ochre, burnt umber, cobalt blue.

Stage 1 *(page 86)*

Make a careful drawing of the subject. Make no attempt to add detail or tone but concentrate on proportion and size.

Put in the main background colours with a diluted wash of cadmium orange and bright red. Try to retain the hard edges around these washes. Put in shadows at the top of the doorway with a mixture of cobalt blue and bright red. Use drybrush here to obtain a broken effect that contrasts with the soft wash of the background areas.

Stage 2

To create the effect of rough stonework, use a mixture of cobalt blue and bright red and drybrush at the base of the pillars where grime has collected. Paint the slim pillars with a no. 1 sable brush, holding it lengthwise and slowly dragging it down the paper once. Using the brush in this way gives a far better result than using just the tip to create a light, feathery brushstroke. Use this brush technique with cobalt blue to paint in the arches and details at the top of the righthand pillar. This is the most critical part of the painting as each brushstroke must work the first time. The painting quickly loses freshness and spontaneity if alterations are made.

Stage 1

Stage 2

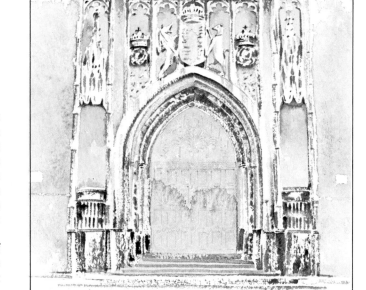

Stage 3

Stage 3

Begin work on the inner arch with quick drybrush strokes of burnt umber, bright red and cobalt blue in varying mixes, together with one or two very thin wash marks of cadmium orange mixed with bright red. When dry put in some cobalt blue to give an effect of broken shadow. Underpaint the wooden doors with cobalt blue mixed with a touch of burnt umber. Use the same mixture for the steps, but put in a quick drybrush stroke in the foreground to give a contrast in texture.

Place a very soft, hard-edged wash on either side of the doorway. The lower part of this wash is a mixture of yellow ochre and burnt umber, and the upper part is a mixture of burnt umber, bright red and cobalt blue.

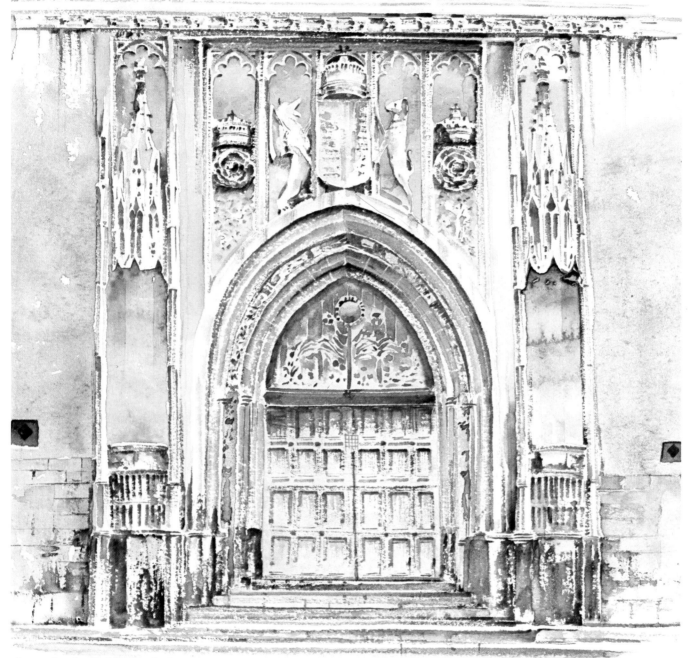

Stage 4 – the finished painting

Stage 4

When the paint on the doors has dried, put in the detail using a mixture of cobalt blue and bright red, taking care to let the highlights show through. Use quick drybrush on the lower part of the doors and slow, darker strokes for the upper part to create an effect of shadow and softer detail. The finishing touches to this painting are very subtle. Put thin washes on the large pillar at each side of the door to give rising vertical planes. Place some very thin washes of cobalt blue on the other areas to give extra relief to the stonework.

Add a few fine wash strokes to the base of the two columns to show the original colour of the stone underneath the grime. Give body and detail to the wall on either side of these pillars with some hard-edged strokes of burnt umber mixed with cobalt blue. Put in some lines to denote the pointing between the stonework. Lastly, add some clear water to the outer edges of the wash on left and right to bleed them softly into the white paper.

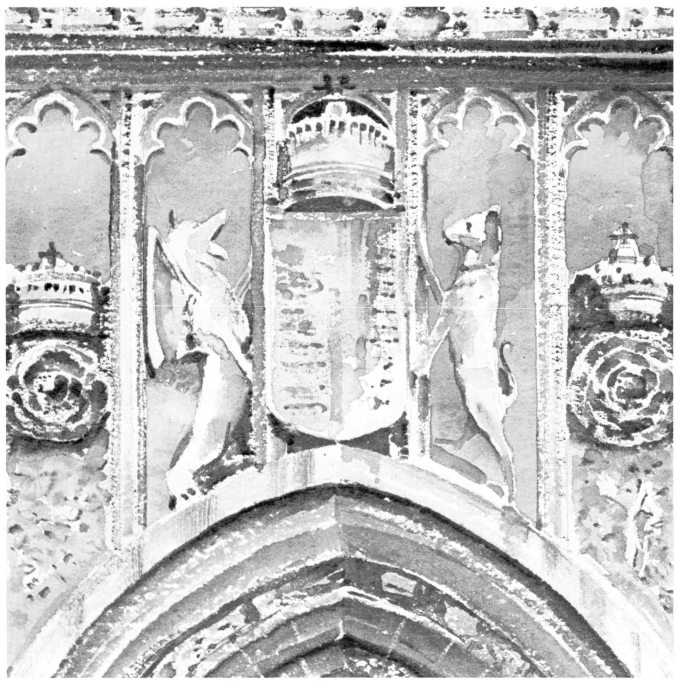

Detail of the doorway illustrated on page 87. This shows the value of drybrush work in relation to slow wet brushstrokes. It is this contrast that gives this painting its sharpness, even when reproduced without colour as with the section on page 85.

Teazels

I discovered these teazels growing amid a profusion of weeds by a wall. They made an interesting subject and a strong contrast to the shadowy mass of growth behind. The planning and execution of this painting was quite different to the others in this book and although the end product looks spontaneous, it needed careful planning.

Demonstration

Size: 254 × 254 mm/10 × 10 in. Paper: T H Saunders NOT 180gsm/90 lb. Brushes: Chinese bamboo no. 9, 1 sable. Colours used: cadmium yellow, cadmium orange, cadmium red, yellow ochre, Prussian blue, cobalt blue.

Stage 1

Make a very simple drawing of the stems and four heads. Apply a little masking fluid with a fine brush to the spines.

Stage 1

Stage 2

Stage 3

Stage 4

89

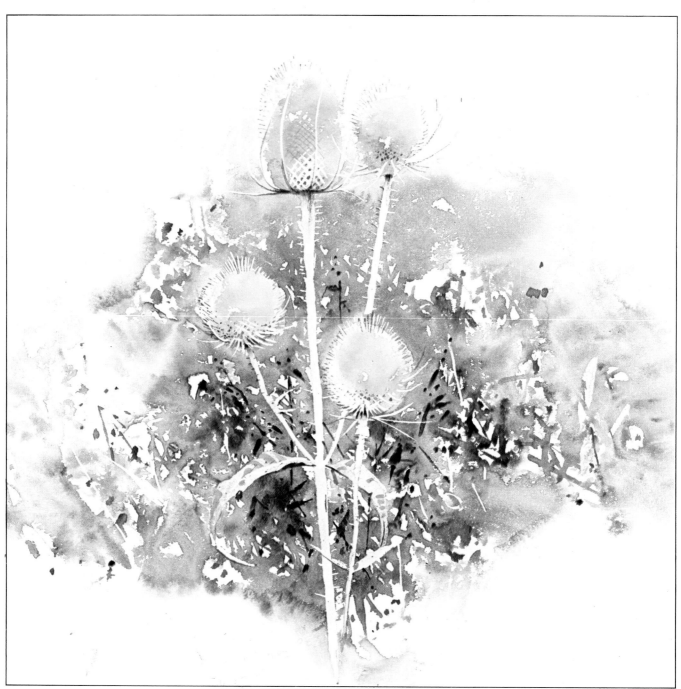

Stage 5 – the finished painting

Stage 2

Make a pale wash from cobalt blue and cadmium yellow and paint in the stems. Mix yellow ochre and cadmium orange and put in a very soft wash on each spiky head. Notice how the colour becomes lighter as it progresses upwards.

Stage 3

When dry, use a fine brush to paint the stems with masking fluid and spatter in more masking fluid over the background areas to create patches of light.

Stage 4

Paint the background with two main mixes of colour. Make the dark greens from Prussian blue, cadmium red and cadmium yellow. Make the light greens from cobalt blue and cadmium yellow. Use a separate brush to apply each colour and work quickly leaving no time for the paint to dry and create hard edges. The wet colours flow into one another to give a loose spontaneous effect. Brush some clear water on the left and right extreme edges of the picture so that the colours fade away into the white paper. When the background

90

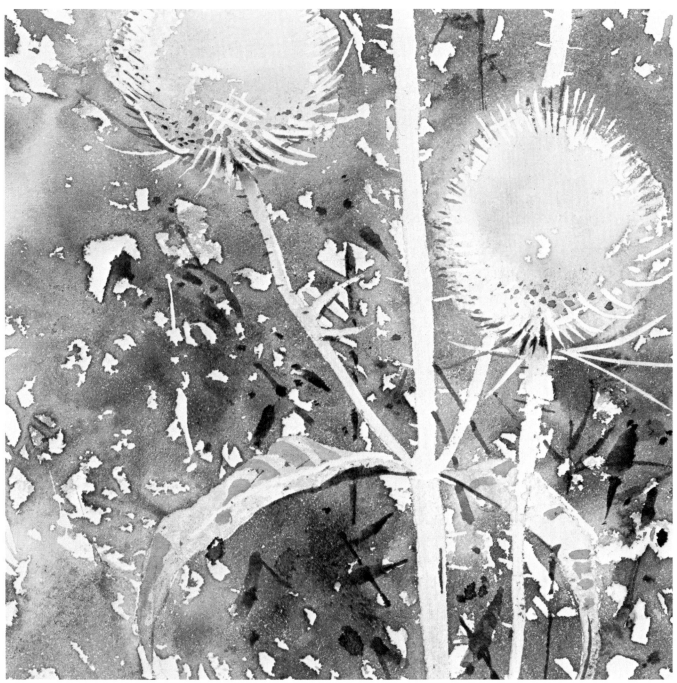

Detail of the teazels on page 90

has dried, put in a few dark dots of Prussian blue to create shadows.

Stage 5

Put in some dark brushstrokes behind the teazel to give deeper shadows. Mix a lighter green from the same colours and put in markings on the teazel leaves and the sepals at the top of the stem; with a fine brush, flick in some sharp lines around the edge of each teazel to create spikes. Take care not to make these details too dark, for their purpose is to bring the teazel into sharp focus against the blurred mass of undergrowth behind.

Advanced Techniques
by John Blockley

Introduction

In this chapter, John Blockley introduces an exciting series of paintings which exploit a number of special techniques. Although these techniques are genuinely useful they can never replace the foundation skills of wash, composition and colour sense, and are recommended in order to enhance them.

These devices build upon the traditional backgrounds to express specific characteristics such as surface textures, roughness, smoothness, and in particular, hard and soft edges. They can enhance the mottled surface of eroded stone, or the glint of light upon rock.

Masking fluid has already been introduced; here, however, John Blockley develops its range considerably. For example he shows you how to dip a pen in diluted fluid and spatter it on a painting to give areas of speckled light.

Other techniques are described too – such as using the handle of the brush in various ways; blotting areas of paint with absorbent materials to create interesting textures; and also how to use the fascinating technique called 'wax resist'. This deposits wax on the rough surface of the paper, and resists a subsequent colour wash. It is an excellent way of creating irregular, weathered surfaces, for example in old walls.

The following paintings use combinations of these processes, and details of the final paintings have been extracted to illustrate particular techniques.

Demonstration

Size: 216 × 216 mm/8½ × 8½ in. Paper: Bockingford 295 gsm/140 lb. Brushes: 12, 8, 6.

Stage 1

This demonstration shows the basic use of masking fluid and how to control dark, heavy washes that suggest a wet, mounting atmosphere.

Outline the cottages in pencil then paint them in with masking fluid. Immediately wash the brush thoroughly in water so that the bristles are not damaged.

When the masking is dry, paint diluted raw sienna over all the paper and blend some cobalt blue into the top left corner. Mix burnt umber with a little French

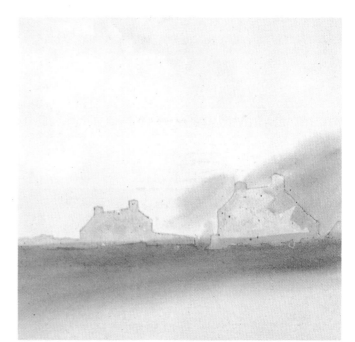

Stage 1

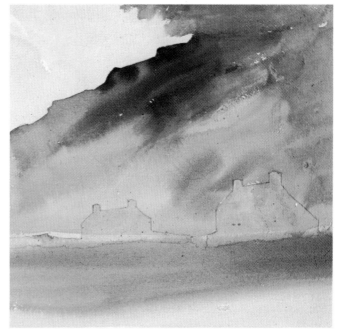

Stage 2

Demonstration

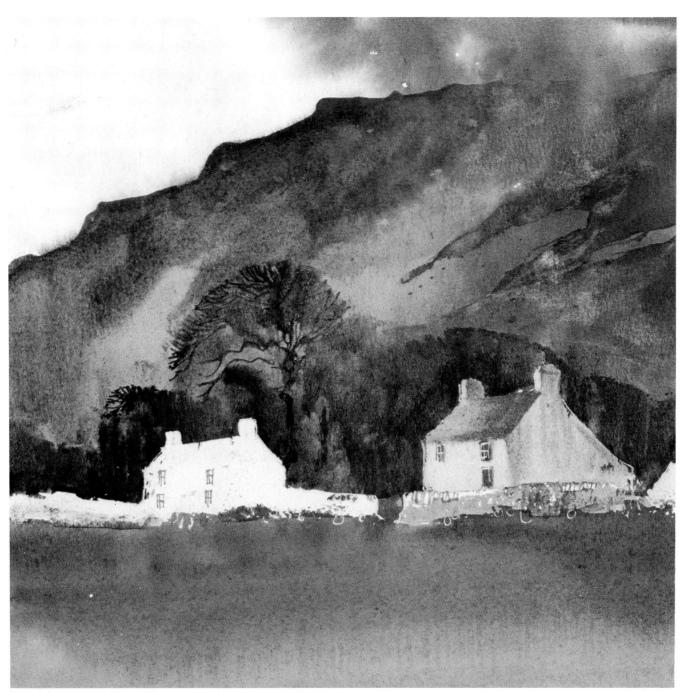

Stage 3

ultramarine, then brush it into the raw sienna ground wash just below the cottages and into part of the background. Let the paper dry.

Stage 2

Dampen the upper sky and parts of the paper above the cottages. Brush French ultramarine mixed with a little black over the mountain area. This wash softens into the damp parts of the paper but is hard-edged on the dry parts.

Stage 3

Develop the shape of the mountain and wash a band of dark colour to suggest a background of trees. Then, with a fine brush draw the tall tree carefully. Now for the exciting moment: with your fingertip gently rub the masking away to reveal the white cottages. Complete one cottage with a wash of raw sienna. Add burnt umber to the roof, end wall and windows. Finish the painting by adding colour to the remaining white shape.

Detail 1

Detail 2

Detail 3

Detail 4

Misty lane demonstration

Detail 1

Dampen the paper in the background and paint in the tree trunks with a slightly damp brush. As the paper is drier at the top, harder lines appear. Now draw the thinner branches over a damp background with a stick dipped in paint. This gives a delightful contrast between sharp, scratchy twigs in the foreground and soft foliage and branches in the misty distance.

Detail 2

Gently rub parts of the paper with a wax candle where the stones of the wall will be. Brush soft colour over it and then draw the joints between the stones with a stick dipped in paint. The lines will be sharper and darker as the paper dries out. Blot away a few stones to make highlights in the rocky texture.

Detail 3

Blend yellow ochre and very little raw sienna into a damp wash, using downward strokes with a flat brush. While this is still damp draw lines into it with a pen and watercolour. Use a thin, blunt stick and gently scratch a few white lines into the paint in this grassy area.

Detail 4

This area has a rough, graduated wash over it. To create the small irregular shapes, remove patches of damp colour with a corner of blotting-paper. For larger blotches use intense fingertip pressure on the blotting-paper.

Misty lane demonstration

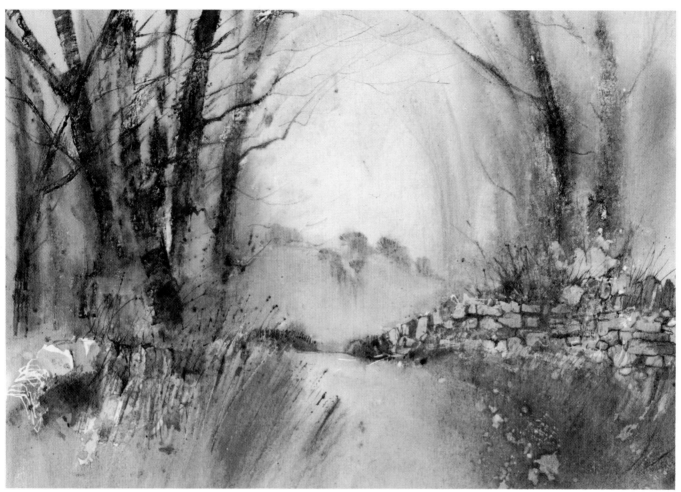

Misty lane – the finished painting

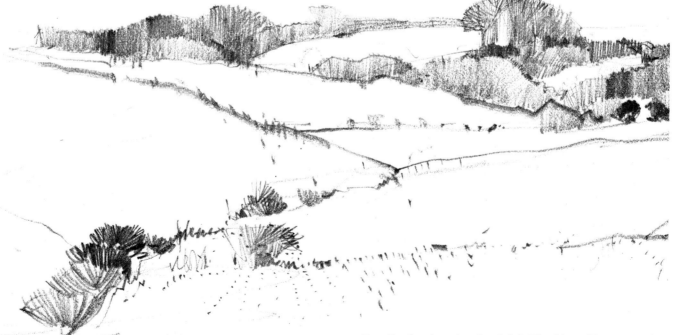

Detail of a drawing by John Blockley. 'Draw as often as you can,' he recommends, 'in all weathers.'

Welsh cottage

Detail 1

The basic wash here looks very sombre until you create soft-edged patches of colour by applying intense pressure with your finger, wrapped in a piece of cotton cloth.

Detail 2

The doorway is just a dark hole until you define the woodwork and lintel with a pen dipped in watercolour.

Demonstration

Size: 299 × 299 mm/11¾ × 11¾ in. Paper: Bockingford 425 gsm/200 lb. Brushes: 12, 8, 6.

Stage 1 (*page 97*)

When finished, this painting has a dark, dank atmosphere produced by successive washes of heavy colour. The most important areas are the light ones and these must be handled with great care at the outset. Draw the outline of the cottage and windows. Mask the chimneys and wall of the cottage, and draw a few lines on the shed door too. Now wash a pale grey mixture over most of the paper, adding a little blue to the top right-hand corner, and raw sienna and vermilion to the bottom: stronger, warmer colours in the foreground bring this area forward. Do not try to define the roof – it is the same grey wash as the background. Blot away colour from the path leading to the front door. Let the paper dry.

Stage 2

Paint a dark background, leaving it hard and crisp round the edge of the mountain. With a moist brush lift out background colour above the roof, using downward brushstrokes. Use horizontal strokes across the roof with a tiny amount of bright colour leading away from the base of each chimney. Bring the dark background around the sides of the cottage on to the wall; blot away soft patches within this area to begin the different textures. Soften the edges of the front path with a moist brush. Do not colour the pathway. In some parts of the foreground blend in the darker brushstrokes of colour.

Stage 3

Darken the background slightly down to the edge of the roof, taking care not to have too much of a contrast. Moisten the edge of the mountain at the top right to break down the hard edge between the mountain and the sky. Gently blot away some of the blue at the very edge of the mountainside to give the impression of strong light coming from behind it. Work more dark colours into the background and foreground and create streaks of grass below the wall by using the wooden end of a brush to rub lines into the paper surface. Let the paper dry.

Detail 1

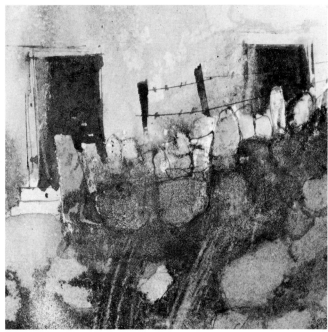

Detail 2

Welsh cottage demonstration

Stage 1

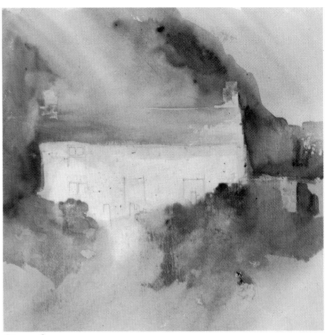

Stage 2

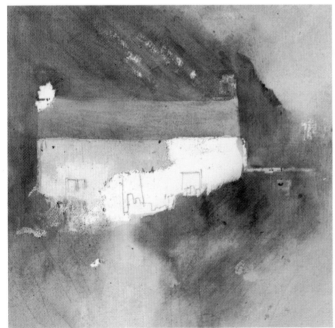

Stage 3

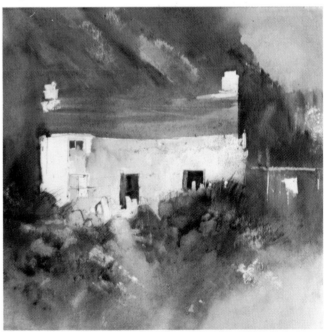

Stage 4

Stage 4

Remove all the masking, and draw in the fine lines of the windows and doorway with a sharp pen. Work dark colour into the apertures and then put a very pale wash on to the front of the cottage. Scratch out one or two white areas on the mountainside and in the foreground. Give the wall more texture by outlining stones with dark paint on a brush. Blot out some stones and add small dabs of burnt umber to enhance the patchy effect. Suggest the grasses along the top of the wall with sharp, pale brushstrokes and a pen and watercolour. Carefully outline the gate posts and capping stones.

Stage 5 (*page 98*)

Emphasize light foreground shapes by surrounding them with dark background colours, dampening the paper locally before doing so. Use a stick dipped in paint to draw a few rocks in the wall and scratch out pale grasses with a clean stick. Wash a pale slate colour over some of the top stones and the gate posts, and introduce it across the front of the cottage to create harmony of tone. Soften the dark door and window areas with a damp brush to give depth to the rooms inside. Work some streaky lines across the roof with a clean stick and a pen. Put in the guttering and define

Welsh cottage demonstration

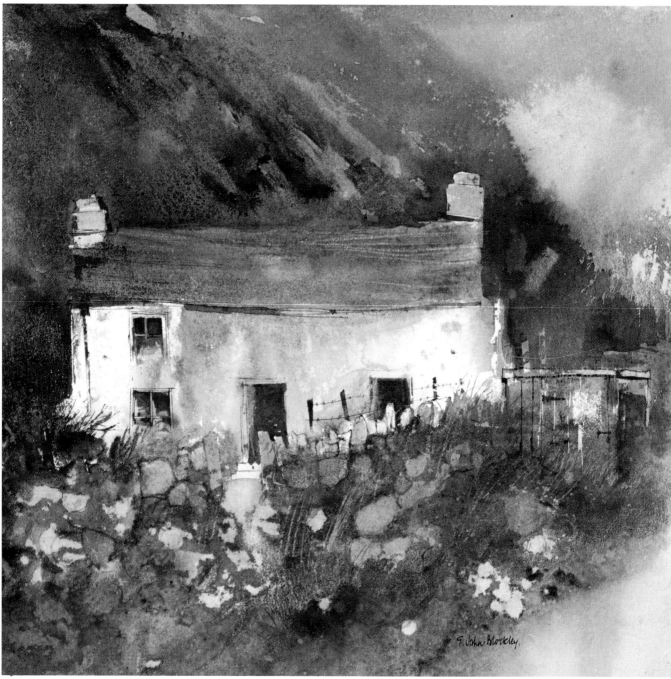

Welsh cottage – the finished painting

the chimneys. Draw some dark lines and rusty nail-heads on the shed door: the hinge and latch give a final touch of detail and character.

As the paper dries out, add sharper definition with a fine brush and a pen dipped in watercolour. Put in the posts and barbed wire to emphasize the starkness, and finally scratch in a few bright flecks on the wall, mountainside and shed with a razor-blade.

Roadside trees

Detail 1

Paint the distant trees with vertical strokes of a round brush, and the trees in the foreground with sideways movements of a painting knife dipped in colour. This treatment leaves areas of bare paper that give interesting bark effects.

Detail 2

Outline some stones with the rim of a wax candle, and rub the side of the candle over other stones. Paint colour over the stones and while this is wet, stipple soft-edged dots with pigment on the end of a pointed stick.

Detail 3

Apply a light wash of cadmium red over the paper. Let it dry, then rub some parts lightly with a candle. Apply a darker wash, which is resisted by the wax and gives the mottled effect. Draw grass lines with pen and watercolour.

Demonstration

Size: 178 × 178 mm/7 × 7 in. Paper: T H Saunders NOT 295 gms/140 lb. Brushes: 12, 8, 6.

Stage 1 (*page 100*)

Brush diluted cadmium red mixed with a little cobalt blue over the paper. When this wash is half dry, add cobalt blue for the soft-edged distant trees, starting at the top and using downwards brushstrokes. Add touches of raw sienna and cobalt blue mixed with burnt umber into the damp foreground.

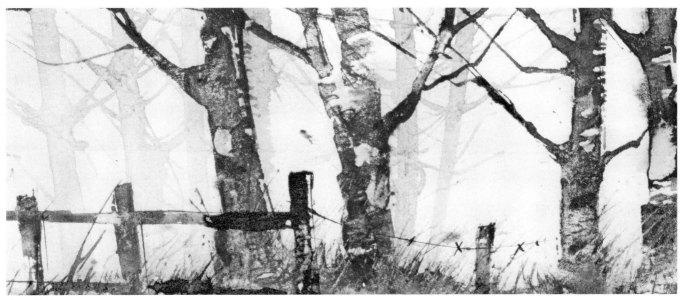

Detail 1

Detail 2

Detail 3

Roadside trees demonstration

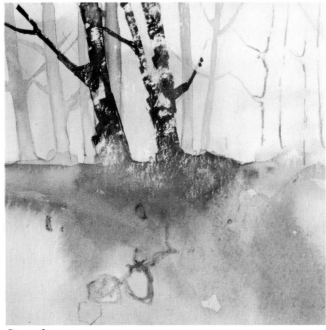

Stage 1

Stage 2

Stage 3

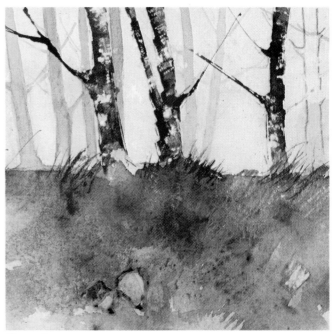

Stage 4

Stage 2

When the paper is dry, paint the trees with pale cobalt blue. Extend some of this blue over the dry foreground, softening its lower edge with a moist brush.

Stage 3

To strengthen the ground at the base of the trees, blend burnt umber into the damp foreground. When the sky is dry, paint the birch trees hard-edged with the edge of a small palette knife in short sideways strokes. To

increase the birch bark effect, scrape the trunks with a razor-blade. Draw foreground stones with masking fluid.

Stage 4

Strengthen the foreground with burnt umber mixed in places with French ultramarine, and from its wet upper edge draw lines of colour with a pen, or fingernail to represent long grasses. Then add the other tree.

Roadside trees demonstration

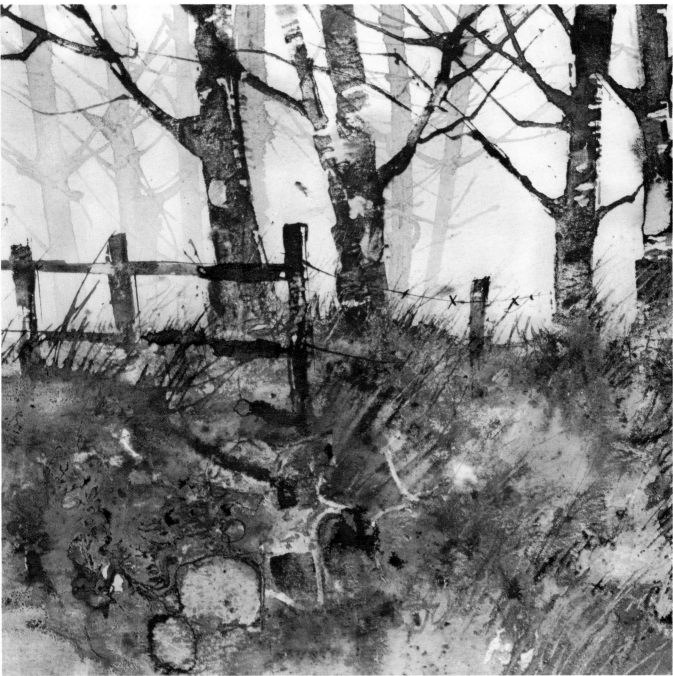

Roadside trees – the finished painting

Stage 5

Dampen random foreground patches and develop them by brushing in darker tones of the existing colours. Give the left foreground texture by brushing ink on to dry paper, letting it partially dry and then blotting it off leaving very detailed edges. I impress the corner of my jersey to achieve the stippled effect on the light rocks and among the grasses on the right. While parts of the foreground paper are still damp, draw in grasses with pen and watercolour: the dry areas will produce hard-edged lines. Flick in tree branches with paint on a stick and draw the fence with a brush. Use a pen for the barbed wire, to add detail to the fence and to a few places in the foreground. When the paper is dry, rub the masking away to expose the stones in the ground.

Moorland farm demonstration

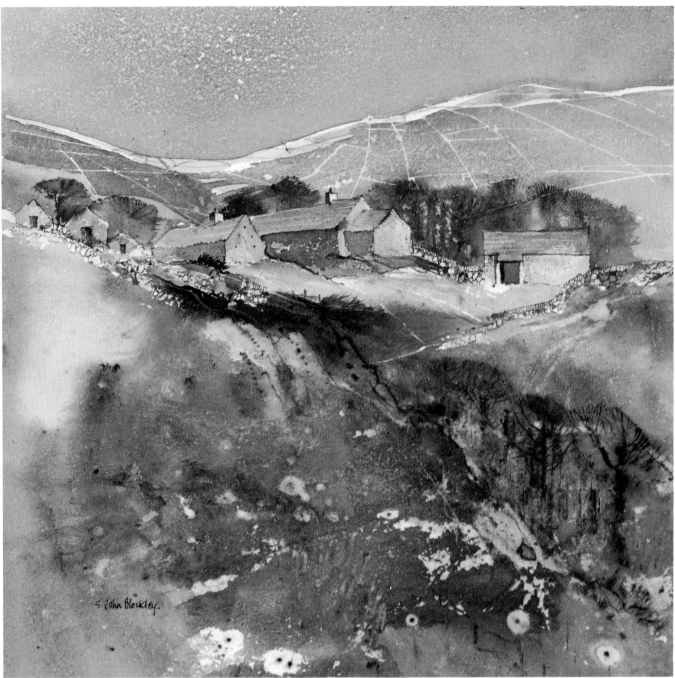

Moorland farm – the finished painting

Detail 4

Paint these trees in the same way as those in detail 3, but strengthen the shape of the tree trunks by drawing them with a stick into the damp tree wash.

Moorland Farm – the finished painting

Begin by masking out the distant field walls, the buildings and the farm walls. Use a brush to spatter the masking fluid at random on parts of the rock face in the foreground. Paint the sky with a flat wash of cobalt blue, then blot out some of the colour from the left to introduce a little light. Brush raw sienna below the buildings.

Dampen the lower half of the paper and brush soft tones of blue-grey and brown madder alizarin into the middle. Then brush in a little burnt umber and French ultramarine and a touch of hookers green. While the paper is still wet, tilt the drawing-board to encourage the colour to diffuse in different directions. Lift out small areas with blotting paper to give lighter tones. Wrap cotton cloth around your finger and blot away more colour, leaving an interesting texture here and there.

When this is dry, remove all the masking. Strengthen the foreground tones and form the trees behind the buildings and in the ravine, as shown in details 3 and 4. Use a stick dipped in colour to define the trees and then brush over the buildings with soft grey, and a little ochre added for warmth. Finally, use a pen dipped in watercolour to draw precisely the stonework in the walls, certain features of the buildings and details of the trees and rocks.

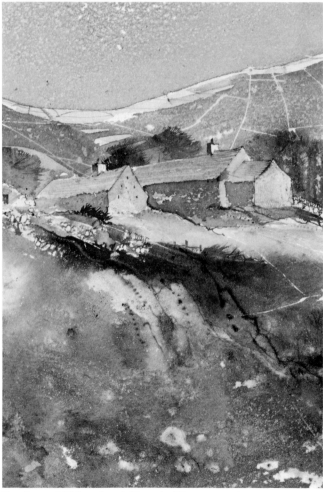

Section of 'Moorland Farm'. The monochrome reproduction shows the balance of tones and textures very clearly.

Estuary

Estuary – techniques

Detail 1 (*opposite*)

Create dark buildings against a light background by masking out the sky and distant hills altogether. Apply a colour wash and remove the masking.

Detail 2

To obtain the light strip of water between the foreground and the mudflats in the distance, apply masking fluid to this area before using any paint. Put it on with a hog brush, as the stiff bristles make the sharp white lines.

Demonstration

Size: 356 × 254 mm/14 × 10 in. Paper: T H Saunders NOT 295 gsm/140 lb. Brushes: 12, 8, 6.

Stage 1 (*page 106*)

Draw the profile of the buildings and the highlight areas on the water with a pencil. Use a hog brush to apply masking fluid around the shape of the buildings and in parts of the water.

Stage 2

When the masking fluid is dry, brush diluted French ultramarine, mixed with a little black, over the paper, and add some brown madder alizarin at the bottom of the paper. When the wash is nearly dry, blend horizontal soft-edged brushstrokes of the same mixture through it. Add a few strokes of hookers green mixed with monestial blue through the lower parts of the water.

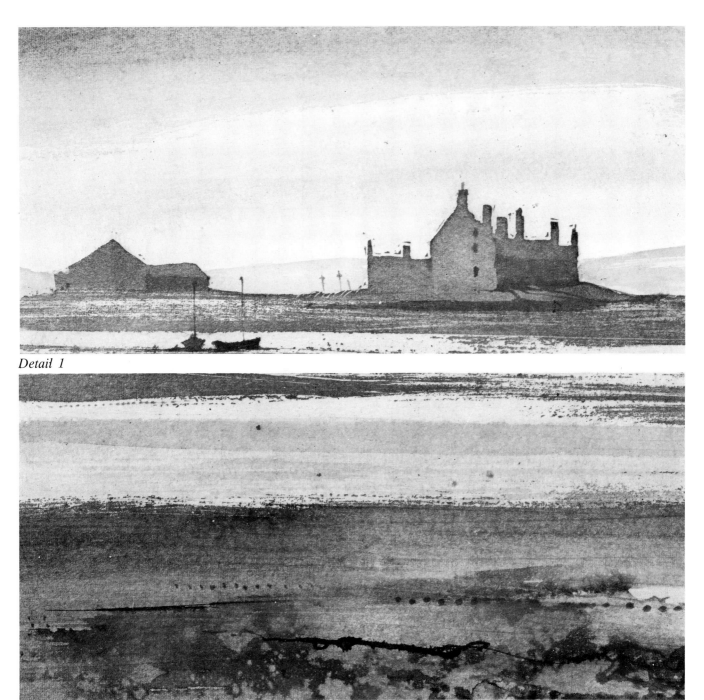

Detail 1

Detail 2

Stage 1

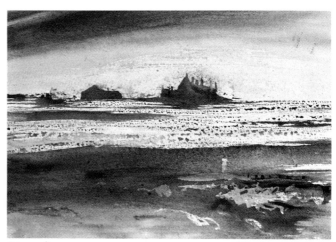

Stage 2

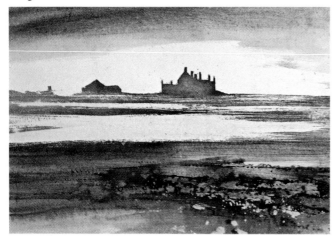

Stage 3

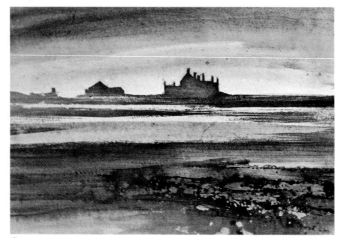

Stage 4

Stage 3

When the paper is quite dry, rub the masking away to expose white paper for the lower sky and light streaks in the water. Now the buildings and mudflats are hard-edged dark shapes. Blot away some colour from the brown madder alizarin at the bottom of the picture to suggest a rocky, muddy foreshore.

Stage 4

Tint the light part of the sky with very diluted yellow ochre, and into this blend a pale blue cloud. Leave the paper white for the horizon. Add some of the blue used in the sky to the water, leaving only narrow strips of light still showing. Strengthen the buildings with darker tones and strengthen the mudflat below the building with brown madder alizarin.

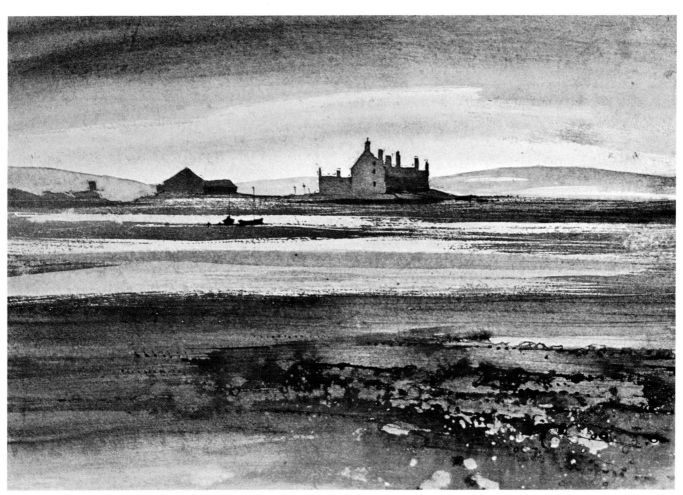

Estuary – the finished painting

Stage 5

Make the finishing touches. Draw two boats and the windows of the buildings with a fine brush and add distant hills in pale blue. This creates highlights across the water with crisp edges in contrast to the softer tones of the sky and foreground. Make the mud flats in the foreground more interesting by working into them with a stick dipped in burnt umber. Draw small rocks and stones and soften some of these shapes with water when they are dry.

This is a simple painting with little added to it after the basic washes are laid over the masking fluid. The use of a hog brush gives an excellent water surface effect. Minimal use of colour produces a strong source of distant light.

Painting Flowers
by Sarah Jane Coleridge

Introduction

In this chapter, Sarah Jane Coleridge deals with a very popular area – painting flowers. Many people think that this is an exclusively female preserve. In fact men also find it intriguing to try and capture the colour, tone and form of living flowers. The skills needed are subtle – you will have to achieve delicate nuances of colours – shades of pink, pale lemon yellows, quiet blues and vibrant reds. Colour mixing is all important, but with practice you will soon learn to find the correct values.

Try to paint as many different kinds of flower as possible, including those growing in the wild. If you keep on struggling with the same bunch of roses for example, your enthusiasm will soon evaporate. Perhaps some of the paintings included here contain flowers which are unfamiliar to you. This should not deter you, however. A sunflower may look different in structure to a daffodil, but basically the same principles of colour and texture apply, and you can relate them to any flowers that you wish to paint.

Learning to work with flowers will provide you with an enjoyable extra dimension to your watercolour skills. You will discover that the unique form of a petal or a leaf can be as challenging in its own way as a major landscape or study of the ocean.

Working method

It is easier to paint flowers indoors as the arrangement remains still and you are not distracted by inclement weather. As I do not have a studio, I usually work in a bedroom and sit at a window sill with the flowers in a vase in front of me.

After setting out paper and paints, pick a small bunch of flowers. If you do not have a garden, buy flowers from a market stall, as they are usually more expensive at a garden shop. I try to incorporate a plan of certain colours into a picture, for example, yellow roses with blue surrounding flowers, or a bright red and yellow colour scheme as in the poppy painting on page 116. Collect flowers with a colour scheme in mind rather than picking anything you can find. Do not pick more than you really need, as flowers do not look fresh for long after being indoors. Arrange the flowers in a vase in front of where you work and decide which flower to paint first.

Begin by lightly drawing a careful outline of the first flower so that it can be rubbed out later on. Be particular when drawing a flower and study the shape carefully. An inaccurate drawing will cause much dissatisfaction with the finished painting. It is not easy at first, but with a little practice you will quickly improve. Keep all your early drawings, as it is constructive and encouraging to glance back at your first pictures and discover that you are gradually improving!

Use a no. 1 watercolour brush to apply a little water on to the paper where the flower is drawn. Do not make the paper too wet or let the water run over the pencil edge; the paper must be moist enough to absorb the first wash of paint quite easily, without it appearing scratched or rubbed on to the paper. Examples showing how to apply paint to paper are opposite. In example 1 the brush and paper were too dry and the paint has not sunk in but has had to be worked on to the paper, producing a dry effect. Experiment on a spare sheet of watercolour paper and discover for yourself how much water you need to put on the brush and paper before tackling the first flower. At first the technique is tricky to grasp, but it will soon develop.

To paint the petunia in example 4, mix together a little alizarin crimson and rose doré. Make sure the paper is still moist and apply a light wash of pale pink. Keep this first wash light in colour, or the contrast between the light and dark colours of the finished

Example 1 – wrong

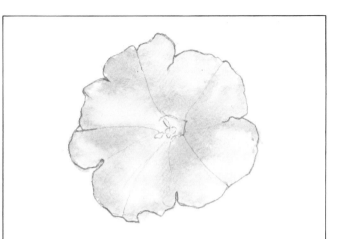

Example 2 – right

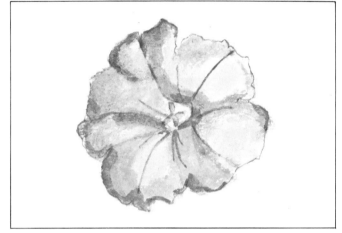

Example 3 – wrong

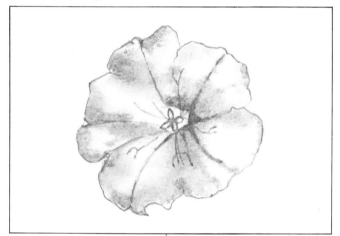

Example 4 – right

flower will be spoiled and the flower will appear rather heavy and flat and lose its delicate translucent effect. When you have painted the first wash, mix a darker shade of the pink, add a little cobalt blue and apply this colour where a deeper shade of pink is needed. At this stage, the first wash of paint must be damp, or the second wash will not be absorbed effectively; and instead of the washes merging together, the second wash will appear hard and dry leaving a noticeable line.

Sometimes if the paper is too wet, the paint dries unevenly and leaves a thin darkish line of colour around the flower. When this happens, take a damp brush, carefully lift out the dark line.

At this point, there are two shades of pink on the flower. Now mix an even darker shade of the original pink and paint in the very dark areas of the flower, for instance, the flower centre and where one petal overlaps another. Add the fine little veins which are often visible in the petals, drawing them in carefully with a fine brush. Finally, lightly rub out the pencil outline.

Remember to try and paint what you see, and give enough detail and work to a flower so that it looks reasonably life-like. Do not overwork the details or the flower will become too botanical in appearance.

Example 1 – wrong

The paper was too dry when the petals were painted and so produced ugly patches giving a scratched appearance. Keep the paper moist enough to float the paint evenly and try to put the paint on in one go; a double-layered wash loses luminosity.

Example 2 – right

A good moist background has encouraged the paint to disperse softly.

Example 3 – wrong

The dark shadows added after the first wash were too hard and strong causing the whole flower to look messy and unrealistic.

Example 4 – right

Areas of soft dark shadow were dabbed on while the first wash was still wet which gives a delicate effect. If the first wash has dried, put blobs of water on the petals and let them disperse, but take care not to leave hard thin edges.

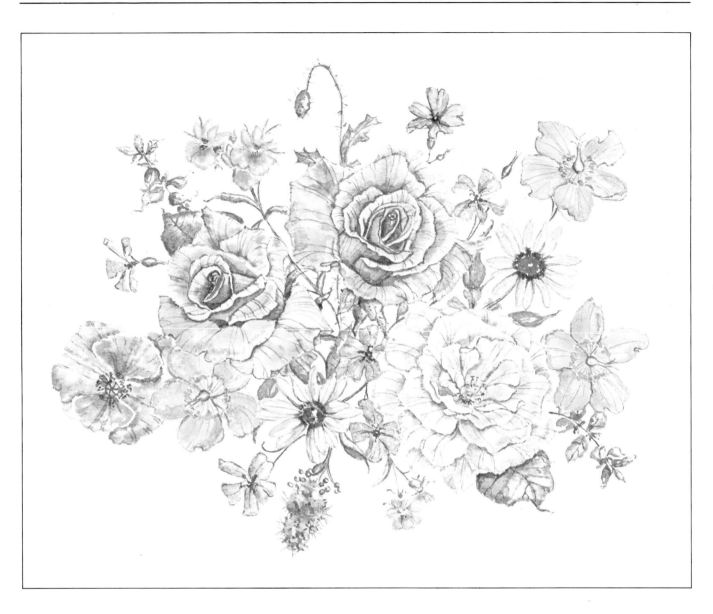

This painting looks far more difficult than it is. I began with the large blooms and added in smaller flowers one by one until the right balance was achieved. The greatest challenge was to paint the white rose and orange-centred dimorphothecas. The large white rose has a very soft wash across its petals and is painted mainly in grey, with a little lemon yellow at the base of some of the petals. Mix some burnt umber with the grey and paint the veins of the petals on to a dry background. The other two daisy-like flowers have a very pale orange wash across the petals – they are far from being just white paper. I used Naples yellow on the three large yellow flowers as it is more opaque than lemon or cadmium yellow.

Leaves

Leaves are an integral part of painting flowers. Used carefully in an arrangement, they provide balance in colour and shape and offset flowers to great effect. Leaf colours, shapes and textures are extremely varied; study them in the paintings in this book and notice how many of the paintings would be very dull without them.

A rose leaf is an easy leaf to paint. It has an attractive shape and I often include it in a painting where there is a problem with composition. When painting a rose leaf, notice the reddish-brown colouring at the base of the leaf and at the jagged edge of the point. Put in the fine veins, as a few small details like this give credibility to a painting. Experiment by painting some unusual-shaped leaves. These are good subjects if you can find them. Nasturtium has a round shaped leaf with effective markings, but quite difficult to paint. Polyanthus has a cumbersome leaf that looks excellent if you are able to capture the rough texture and the fresh bright green colouring. Daffodil is a beautiful blue-green colour but is awkward and long. To counteract this, I sometimes place this leaf behind a flower thereby suggesting a large leaf without actually showing it.

Do not use too many leaves in one painting or the abundance of green will kill the sparkle in the work. Use variegated leaves such as those of ivy or periwinkle to give relief from too much green.

Light

Light gives sparkle and a certain life to a flower painting. Without light, a flower looks flat and dull. Study the single rose and leaves on page 113 and notice the effect of the pale undercoat contrasting with the different shades of green on the leaves. If dark green had been painted all over the leaf, the effect of light would disappear, leaving a flat plane. Study the flower you are painting and see the areas where light falls on the petals. Leave these parts very light and the painting will have more impact.

I never use white paint when using white watercolour paper. To achieve a light effect, think ahead and plan which areas need to be left white before putting any paint on the paper. If you do use white paint for the highlights, you will lose some of the translucence that is so important in watercolour painting.

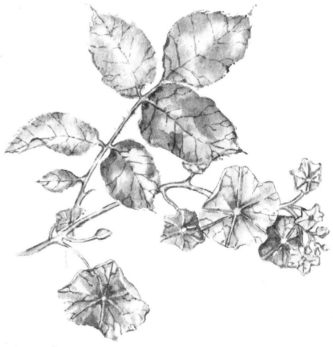

Example 1 – wrong

Example 2 – right

Example 1 – wrong

These leaves are flat and have no life as the basic wash is not graduated.

Example 2 – right

The same leaves are more varied here due to the way the wash was applied. Leave areas of white and incorporate hard and soft lines in the leaf colours as well as in the veins.

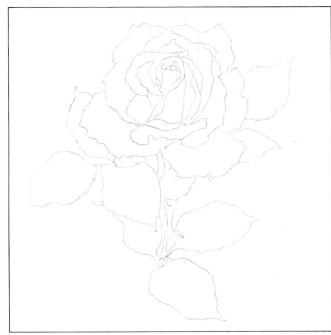

Stage 1

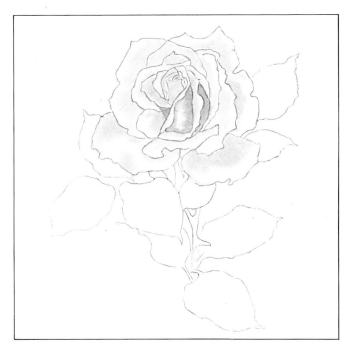

Stage 2

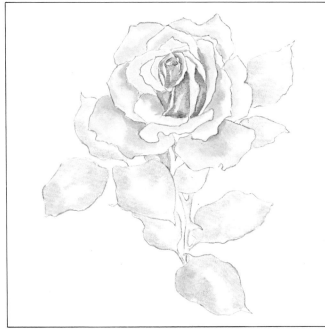

Stage 3

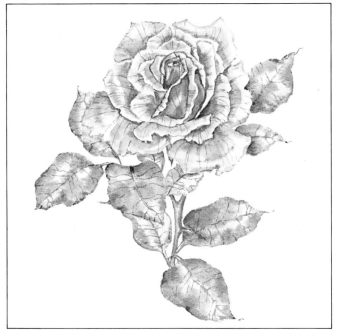

Stage 4

A single rose demonstration

Stage 1

Draw in the outline of the rose, taking care to do it lightly so that it is easy to erase.

Stage 2

Wet the flower head and put in a very pale alizarin crimson wash. Work on no more than two petals at a time and use rose doré for the darker petals but leave plenty of white on the outer edges. Put pale lemon yellow wash over the leaves, using a very small amount of paint.

Stage 3

Put a second wash over the base of the petals, using cadmium red for variety. Make sure the leaves are still slightly moist and then add sap green and cobalt blue mixed in varying proportions for the darker areas and leave areas of pale yellow to show light. A subtle variation in colour is already apparent on the leaves.

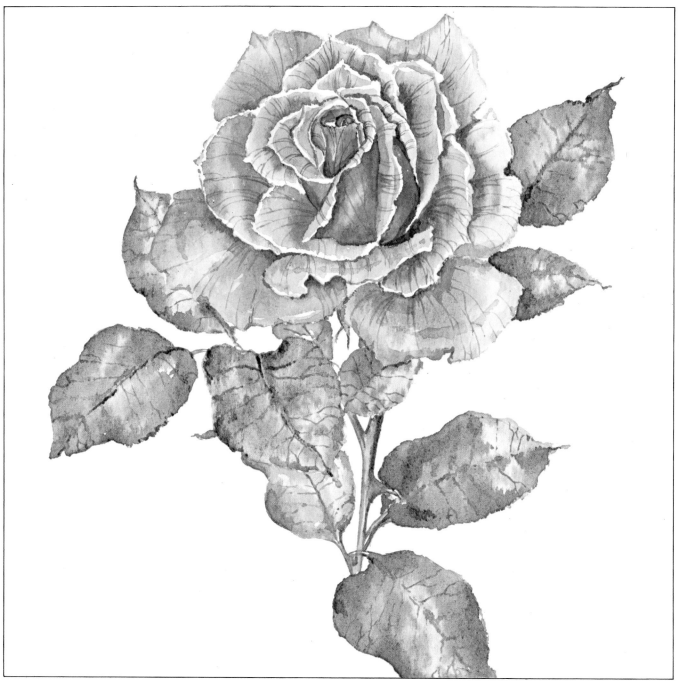

Stage 5 – the finished painting

Stage 4

Strengthen the colour of the petals by adding cobalt blue to alizarin crimson. When there is enough colour on the leaves and petals, paint the veins with a mixture of cobalt blue, sap green and burnt umber. On no account use black to do this. Do the veining when parts of each leaf and petal are still moist so that a broken line is produced with hard and soft edges.

Stage 5

There is very little difference in these last two stages. If all the work on this painting is successful so far, then all that remains to be done is to bring out the softness of the rose. It looks a little harsh in stage 4, so soften some of the edges of the veins on the leaves and petals. Be extremely cautious when doing this as too much blending will result in loss of character.

This is an example of how an arrangement of large shapes lacks interest and looks dreamy. Add small flowers and other details and this will give it freshness.

Arranging flowers

There are two ways of working, either arrange the flowers into an attractive group before painting, or arrange them as you paint on the paper. I use the second method and without any preconceived arrangement in mind, I build up the picture flower by flower as I paint. If you are familiar with flowers, then this is a successful method and intuition will prevent mistakes. Disasters do happen, but it is still possible to save a painting.

I begin by painting the main flower and usually two or three others. I then add smaller flowers and leaves to complement the main flowers. The painting of poppies on page 116 was produced in this way. I painted the poppies and then introduced other interesting flowers and foliage. Note the effectiveness of the small poppy buds: without these and the dangling daisies, the painting would look too solid. The drawing above of a poppy arrangement without any small flowers illustrates the point perfectly.

The main points to remember when arranging flowers are to compare and contrast colours, shapes and textures. This will produce interesting paintings and ensure against using the same design.

Front view of Shirley poppy

114

Poppies demonstration

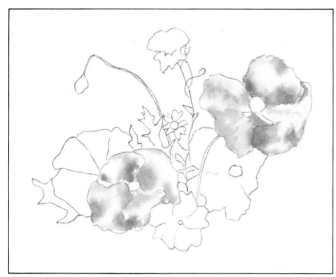

Stage 1

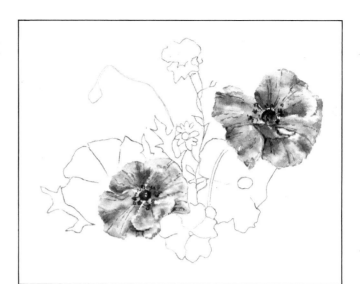

Stage 2

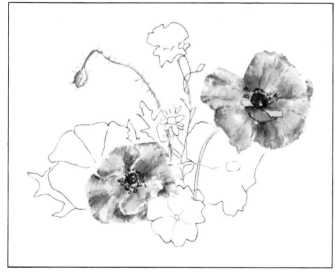

Stage 3

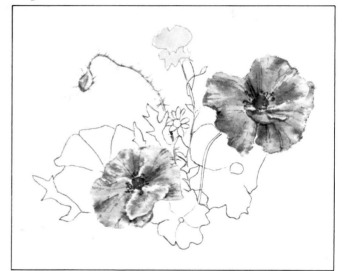

Stage 4

Poppies demonstration

Stage 1

After drawing in the outline of the poppies, begin work on one flower head and wet some of the petals. Let the water soak into the paper and then dab paint on with a no. 1 sable brush but control the diffusion carefully. The colours used are lemon yellow and cadmium red. If you put on too much paint, lift out excess colour with a clean moist brush.

Stage 2

Work just on the two poppy heads until they are complete. While the paper is still moist, blend in subtle shades of red made from different combinations of cadmium red, lemon yellow, cobalt blue and burnt umber. Paint a stigma in the centre of each flower with dark cobalt blue. Add the thin dark lines on the petals

with a no. 0 sable brush. Paint into both dry and wet paper to achieve a broken line. Put in the stamens around the stigma then lay a thin lemon yellow wash over the poppy bud.

Stage 3

Add sap green to the poppy bud while it is still wet. Let it dry and flick fine hairs on to the stem with a no. 00 sable brush.

Stage 4

Put the first pale lemon yellow wash over the nemesia. Use the same procedure to do this as for the two finished poppy heads. Painting flowers in this style is not difficult if you follow these simple techniques, concentrate and above all consider each brushstroke before applying paint to paper.

115

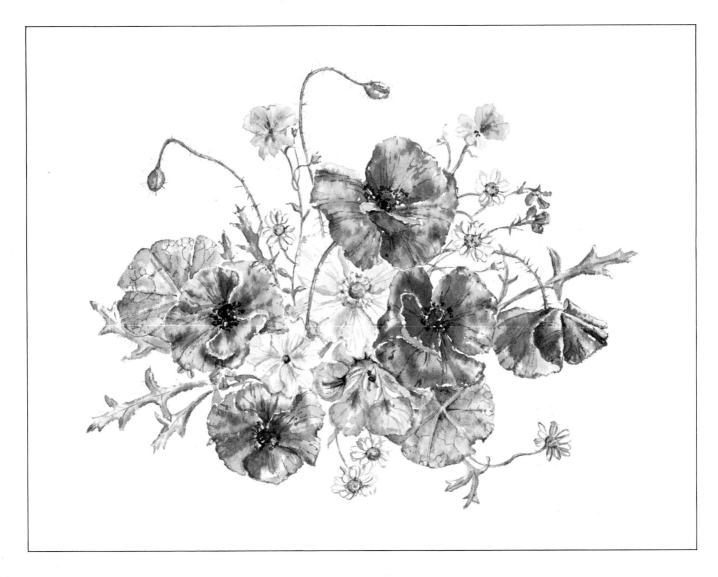

Stage 5

There is a great deal of difference between the last two stages. I am not particularly happy with the finished painting, as all the round shapes make the arrangement too intense but it is saved to a certain extent by the spiky poppy leaves and straggly buds. I had great difficulty in positioning the dark yellow nasturtium as its colour was similar in weight to the poppies. The white flower in the centre of the picture complements the poppies well and provides space between the strong red shapes. The drooping poppy on the extreme right is the most successful as its pose is so striking. The tiny blue flowers contrast well against so much red.

Positioning flowers

The positioning of a flower is very important. Sometimes a flower appears· more attractive if the head is tilted at an angle instead of face-on. Experiment with your flowers and you will understand what I mean. For example, let a daffodil dangle its head over the edge of a vase, or lay it on a book and let the flower head fall to one side. If it is necessary to raise the head slightly, simply support it with a paint tube.

Move the flower into different positions to find its most appealing angle and study the different ways in which the light falls on the petals. Even the back view of a flower can look effective in a picture.

A few daffodils with their heads face-on are on page 119. Compare these with those on page 126 in which two of the daffodils on the left are tilted at different angles. These daffodils appear more realistic and graceful than the others.

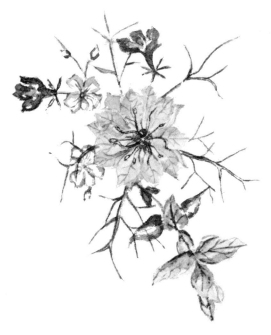

A simple but carefully painted group containing nigella, clary, lobelia and gypsophila.

Colour

When painting flowers in watercolour I attempt to capture the colour of the real flower as accurately as possible. This is not always easy, but as you increase your skill with paint you will have a better chance of achieving the right colour. Do not mix too many colours together or the colour you produce may appear rather muddy. A good rule is to mix together no more than three colours. In the painting on page 119, I aimed to produce a bright colourful picture but that did not appear brash or gaudy. It is easy to use too much colour and ruin a painting, so I try to have two or three bright patches of colour and then use more moderate colouring in the rest of the picture. In the demonstration on page 118, I found the white daffodils with the yellow-orange centres much easier to paint than the plain yellow daffodils. The contrast of the silvery pale petals against the brilliant yellow-orange centre is quite striking. A plain golden daffodil, despite its glorious yellow, can look dull and heavy if you make the dark shadows on the flower too strong.

The polyanthus flower is exciting to paint and these flowers add a great deal of life to a picture as they look so rich and vibrant. Despite this, I avoid the brightest colours as I am wary of sacrificing subtlety for brightness. It is important not to overfill a picture with flowers and leaves. The painting on page 121 was becoming coarse and weighty with too many daffodils and polyanthus leaves. To balance the picture, I included a few small delicate flowers which solved the problem.

Stage 1

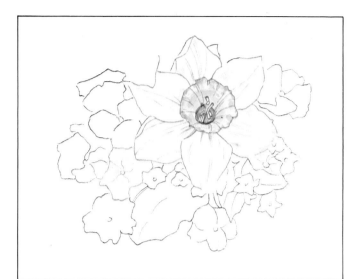

Stage 2

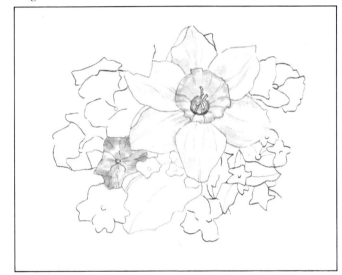

Stage 3

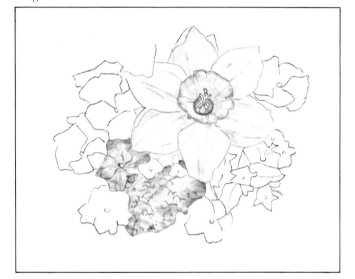

Stage 4

Daffodils demonstration

Stage 1

Make a simple drawing of the central flower and some of the smaller details. Wash pale lemon over the daffodil and then lay a second variegated wash of cadmium yellow over the trumpet.

Stage 2

Make up a grey from sap green and cobalt blue and lay in areas of shadow on the petals, the trumpet and in the centre. When the petals are almost dry, paint in lines to give them form and shape. Lay a lemon yellow wash over the polyanthus.

Stage 3

Paint the polyanthus petals with rose doré and alizarin crimson and try to obtain a soft effect of broken colour. Use cadmium yellow for the centre and when dry, paint in lines which give them character. Lay a pale lemon wash over the large leaf in the foreground.

Stage 4

Work up the colour in the leaf by adding tiny blobs of cobalt blue and sap green on to the wet paper. Watch the diffusion of this colour carefully and ensure that large areas of white remain visible. When the paper is almost dry use the same technique as for the petals, and paint in fine lines to create a realistic texture.

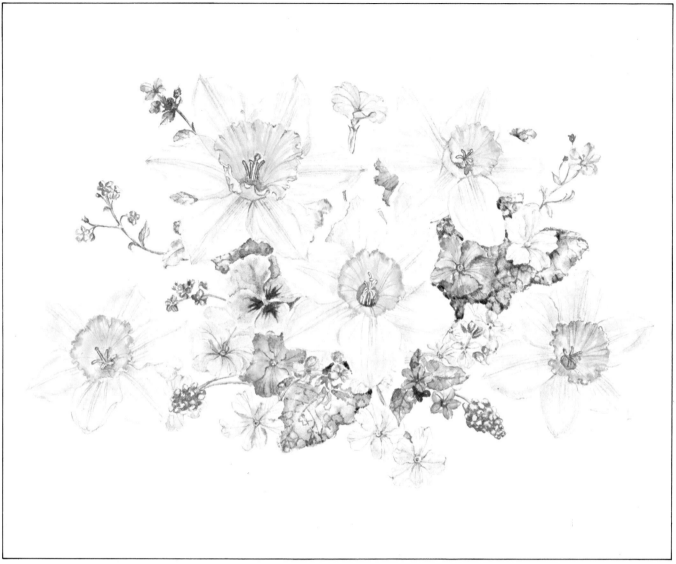

Stage 5 – the finished painting

Stage 5

This painting was done by repeating the technique described in stages 1–4. Painting flowers in this style is not difficult. There are no secret methods or complex tricks.

I think the overall effect of this painting is clumsy as nearly all the daffodils are face-on and the green leaf on the right is too large and dark. Again the picture is rescued by the small flowers. The trumpet of the daffodil on the top left is badly drawn, but the flower in the centre is more successful because the lines that come up and out of the trumpet give it depth.

Flower shapes

Consider the shape of every flower carefully as some types such as aster, chrysanthemum and marigold are much more difficult to draw than others. Though these are lovely flowers, their shape is round and heavy, which makes them tricky to paint successfully. The poppy also has a round and heavy shape, but as it is a very light and flimsy flower, it is easier to paint in watercolour.

Flowers with shapes that are challenging to draw are nasturtiums, fuschias, snap dragons, foxgloves with their lovely bell-shaped heads and majestic gladiolae, which bloom in such delightful salmon pink and pale orange colours.

It is not always necessary to draw a complete flower. In the painting on page 122, I placed a deep red poppy behind the central pink and white one, so that the red one was just hinted at, and helped to show up the paler, more delicate poppy. Draw and paint in part of a flower when you have an awkward space in the arrangement. This is more interesting than trying to squeeze in a complete flower.

Small details

It is important to take particular care in painting stems and buds. It is no good having a pretty flower head on a willowy, badly-drawn stem. Give a stem enough body so that it looks as if it can support the flower head. In the painting on page 122, observe the detail on the poppy flowers such as the little stamens in the centre of the flower. Look closely at the two poppy buds; these are covered in tiny little hairs, which help to make the poppy buds more life-like. Without these small hairs, the poppies look incomplete. I painted the poppies first and surrounded them with gypsophila (the little white flowers), clary (the small pink flowers) and viscaria (the blue-mauve flowers). If you have a garden, sow a few annual seeds as they are most useful in painting this type of picture.

To give a painting interest, put in small buds or half-opened flowers as well as full blooms. Take care over the buds or they will look like small blobs of paint. I find that if a painting turns out satisfactorily, it is partly because I have spent time observing and painting the small details of the flowers and leaves.

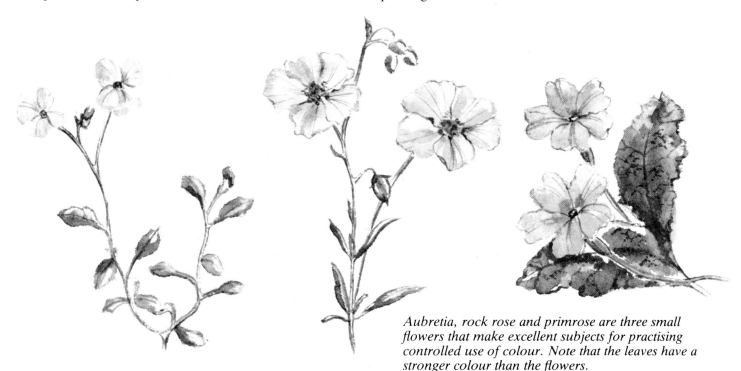

Aubretia, rock rose and primrose are three small flowers that make excellent subjects for practising controlled use of colour. Note that the leaves have a stronger colour than the flowers.

Stage 1

Stage 2

Stage 3

Stage 4

Shirley poppies demonstration

Stage 1

Outline the centre poppy and some of the surrounding flowers in pencil. Moisten the poppy with a little water and introduce very pale washes of alizarin crimson, taking care to keep the outside edges of the petals white. While the paper is still wet, dab lemon yellow in the centre of the flower and at the base of some of the petals making sure there are no hard lines.

Stage 2

Paint a second wash of alizarin crimson on the petals, mix grey from cobalt blue and sap green and apply it at the base of the centre petals to give depth. Use sap green to show the stigma and paint the stamens with dots of cadmium yellow and yellow ochre. Add a touch of cadmium red to the petals but keep the outer edges white so that they seem to sparkle.

Stage 3

Complete the centre poppy by adding veins in pale grey. Begin work on the other two poppies using cadmium red and plenty of water.

Stage 4

Add deeper shades of red and when dry mix cadmium red with cobalt blue and put in the lines and tiny areas of dark shadow.

Notice how the pink poppy is highlighted by the deeper, darker red flower behind it. I often use this composition as I know it works well.

121

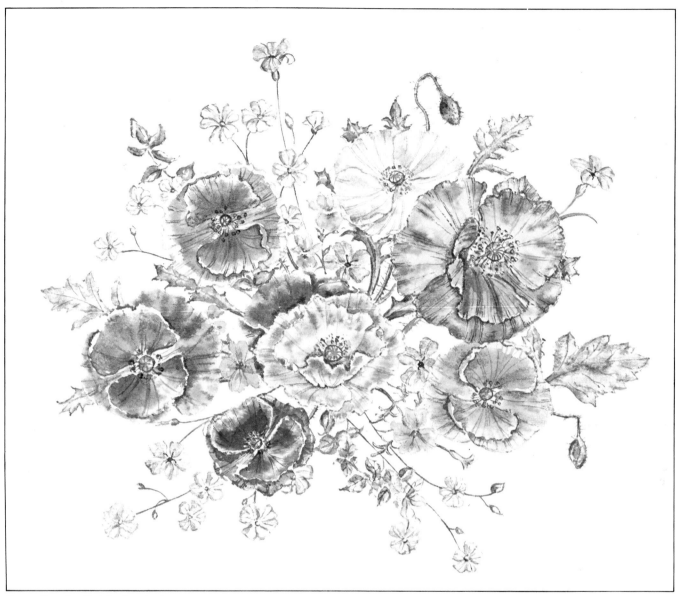

Stage 5 – the finished painting

Stage 5

How you arrange the composition of flowers is your own choice. There are few rules but it is easy to make mistakes when beginning. Try to maintain a balance of colour, form and shape. This does not necessarily mean it has to be symmetrical as visual contradiction often gives good results.

Although I have some reservations regarding the composition of this painting, it does have a pleasing overall effect as there is plenty of light and sparkle from the white edges of the shirley poppies.

Dark shadows and deep colours

Painting the deep-coloured shadows or contrasting the light and dark parts of a flower presents particular problems in watercolour. Remember that it is only necessary to paint what you see, so if a dark shadow is visible, try to paint it exactly as you see it. Without these dark shadows, the flowers may seem pretty and attractive, but they are less realistic and have no depth. Dark shadows throw up the highlights to great effect. To help isolate light and dark areas, look at the flowers through half closed eyes for a moment and the tonal differences may then seem more obvious.

In the painting on page 125, I worked on the narcissi first. These flowers had very delicate pale lemon coloured petals and the two central flowers had silvery white ones. To portray these fragile flowers accurately, I had to paint carefully in greenish-grey shadows to emphasize the petals. The narcissi also had bluish-green stems with hints of very dark green which helped to contrast with the pale delicate petals. The rich yellow colour in the centre of the narcissi also enhanced the petals.

Having completed the narcissi, I worked on the primroses and alyssum, two more delicate spring flowers. When these were finished, I noticed that although these soft yellow flowers looked very pretty, they needed a strong-coloured flower or leaf to give depth to the painting and to bring out the beauty of the pale flowers, so I incorporated several pansies into the painting and found that the mauve and alizarin crimson colour of these flowers achieved this perfectly. A few leaves also provided a contrast to the flowers. I could have added more richly-coloured flowers, but I wanted a very delicate spring picture of mostly lemon yellow flowers, offset by a few deeper coloured ones rather than have an arrangement of many different coloured spring flowers.

Narcissi demonstration

Stage 1

Draw the flower in the centre of the composition. Follow the same procedure described in the other demonstrations. Lay a pale lemon yellow wash over the outer petals and while still moist, paint in the grey mixed from sap green and cobalt blue. Notice that a hard edge is apparent where the paper has dried on the lowest petal. Use sap green for the stem.

Stage 2

Add more grey to the base of the petals and some bright dashes of cadmium yellow to the centre. Give the stem more body by working in a few brushstrokes of darker green and add some burnt umber to the shoot on the left. Erase the pencil line around the edge of the petals and notice how much softer the flower seems. Paint fine grey lines on the petals and then start the same sequence for the next bloom.

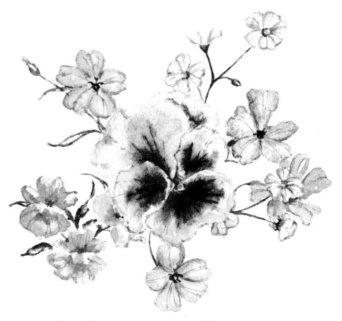

A star-shaped arrangement around a pansy.

123

Stage 1

Stage 2

Detail 1

Detail 1

The large pale blooms contrast well with the small dark leaves and purple flowers. Place the dark flowers behind the lighter ones to create depth and ensure balance. Study the brushwork in this detail and try to determine which strokes were made into wet paper. This analysis shows how easy this style of watercolour painting is.

Detail 2

Detail 2

This section of the painting looks overbearing when shown out of context. The blooms jostle for position and there is little light and air in the picture in comparison to the finished painting in stage 3. This is a good example of the importance of the use of space to create a light effect.

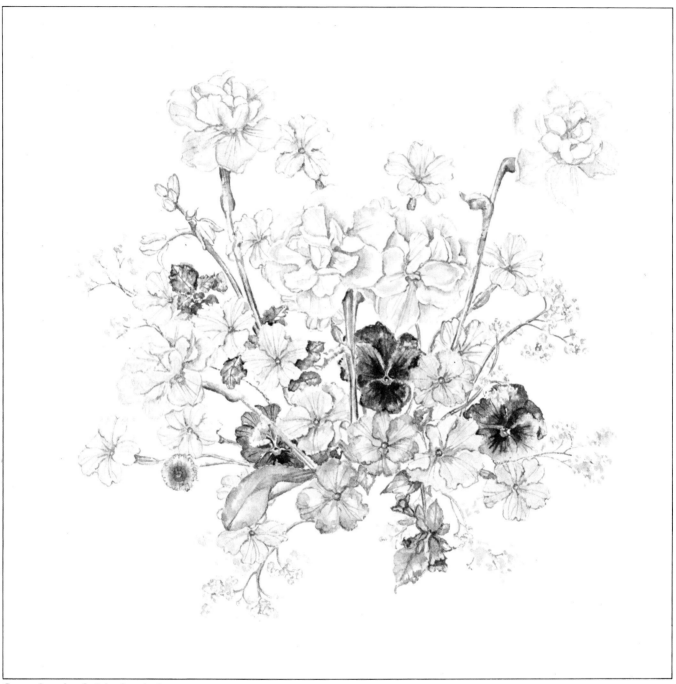

Stage 3 – the finished painting

Stage 3

I struggled with this painting as I was sure it was going to turn out looking too busy. On reflection it works quite well. Although there is a lot happening, the composition is not too tight. The two dark pansies throw out the soft yellows and give weight to a painting that does not have much strong, rich colour.

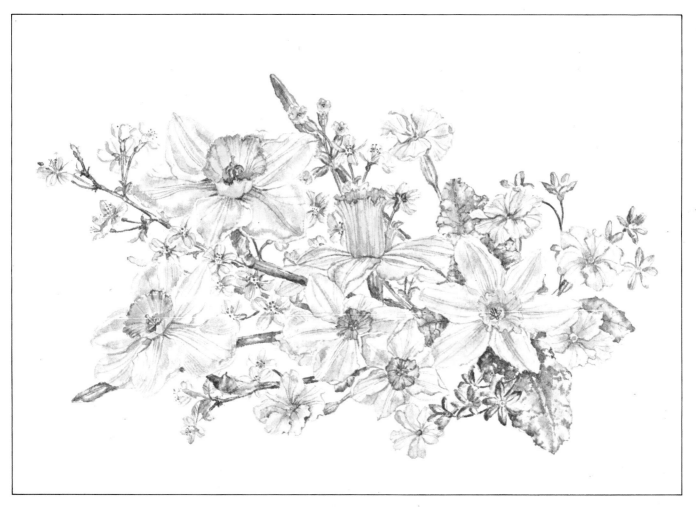

This spring flower arrangement includes daffodils, chinadoxia, polyanthus, primrose, cowslip and a cherry branch. I wanted a predominantly yellow painting and so I used cadmium and lemon yellow for most of the flowers. The large primrose in the foreground on the left has a pale lemon wash over the petals and a little cadmium yellow added to the centre of the flower to give it depth. The orange centres of the two middle daffodils were made by adding a dash of cadmium red to cadmium yellow. Use of grey gives texture to the petals. The grey is a mixture of cobalt blue, sap green and a touch of burnt umber. I also painted some on to the wet petals over the basic yellow wash. Some of these petals have hard grey edges where the paper dried before the colour was applied. The other hard-edged grey lines on the petals were added later. Do not leave out the dark creases at the base of daffodil trumpets or they will look flat.

The upright daffodil in the centre and the one on the right face-on, are positioned at less interesting angles than the two on the left which turned out more successfully.

Index